DRAWING & SCULPTURE

DRAWING & SCULPTURE

MERVYN LEVY

WALKER AND COMPANY, New York

Designed by Edward Burret, FSTD
First published in the United States of America
in 1970 by the Walker Publishing Company, Inc.
Published simultaneously in Canada by The Ryerson
Press, Toronto.

ISBN: 0-8027-0332-1
Library of Congress Catalog Card Number: 71-129566
Printed in Great Britain
Text printed gravure by D. H. Greaves Ltd.
Color plates printed letterpress by W. & J. Mackay & Co Ltd

FOR KENNETH MCMINN

CONTENTS

ILLUSTRATIONS

ANDREA DEL VERROCCHIO
1 Study for a Hercules and putti
2 Tabernacle
3 Study for 'David'
4 Sketches of various figures and putti
5 Study of an angel
6 Study of heads and figures
7 Study for Madonna and Child
8 Head of a woman
9 Study for 'St Jerome and Angels'
10 Christ and Doubting Thomas

MICHELANGELO
11 Wax sketch of a young slave
12 St Anne, Virgin and the Infant Christ
13 The gods shooting at a Herm
14 Tityus
15 Male nude with proportions
16 Bacchanal of Children
17 The Resurrection
18 Studies from the nude
19 Study of a nude torso and heads
20 Study of a horse (detail)
21 The Fall of Phäeton

GIOVANNI LORENZO BERNINI
22 Constantine the Great
23 Design for a mirror for Queen Christina of
 Sweden
24 Study for the altar in the Chapel of the Holy
 Sacrament
25 Study for a Fountain of Neptune
26 Study for a Fountain of Neptune
27 Study for the altar in the Chapel of the Holy
 Sacrament
28 Self Portrait
29 Study for the altar of the Fonesca Chapel

30 Study for the Fontana del Moro
31 Angel holding the Crown of Thorns

ANTONIO CANOVA
32 Seated woman
33 Tree trunk
34 Landscape with classical prospect
35 Eleven dancers
36 Sketch for the Italian Venus
37 Sketch for 'The Graces'
38 Sketch for 'The Graces'
39 Study for 'Venus and Adonis'
40 Sketch for 'Cupid and Psyche'
41 Study of a seated woman
42 Self Portrait
43 The Three Graces

AUGUSTE RODIN
44 Two nudes
45 Nude lying down
46 Nude
47 Two nudes
48 The Metamorphoses of Ovid
49 Two young nude girls
50 Seated nude
51 Three nudes
52 Two nudes crouching

ARISTIDE MAILLOL
53 Nude
54 Reclining nude
55 Reclining nude with black stockings
56 Wood-engraving for Ovid's 'The Art of Love'
57 Thérèse
58 Venus
59 Woman lifting her skirt
60 Dina arranging her hair

PREFACE

THE RELATIONSHIP between drawing and sculpture is so close that at a glance one may miss the intimacy with which the strands of the one activity are interwoven with the body of the other. To some extent this miscalculation is made because the relationship between drawing and *painting* being so widely separated, one is inclined to think of all drawing as a substantially separate and dislocated activity. The concept of drawing as an end in itself springs, of course, from the fact that since there are at any given time many more painters than sculptors, our notion of the place and function of drawing in the overall pattern of the visual arts is largely conditioned by the character and intentions of the drawings of painters. These differ widely from those of sculptors, primarily because the painter often uses the activity of drawing as a form of 'negative' relaxation; as a relatively irresponsible activity in which he can freely indulge any passing whim of self-expression, relieved for the time at least of the necessity to think and act in more elaborate, complex, and artistically responsible terms. Of course, on occasions the painter makes serious and sombre 'studies' for a large-scale project, but in the main drawing is for him a comparatively frivolous and carefree pursuit which he practises as a supplementary—rather than a complementary—act of creation. Hence the vast number of delightful, sensually relaxed drawings of the nude which are a characteristic aspect of the painter's existence: drawings that involve him in nothing more serious or demanding than a spontaneous, fundamentally sexual response to the female form. The greatest masters of painting have shrugged off drawings in this vein, not all of them erotically inspired, but drawings nonetheless in which the sole objective of the artist has been to make a passing notation for no better and no deeper reason than the attraction of the eye to a fragment of nature or life. Rembrandt, Lautrec and Picasso—these, and countless other masters—have frequently indulged the painter's prerogative to cast off aimless sparks and flashes of drawing: delightful, revealing and brilliant, both technically and in terms of feeling and emotive content, but limited by the simple fact that the fragmentation of life into close areas of transient sensory experience is itself circumscribed.

Not so the drawings of sculptors, which are usually and from the outset conceived as total prefigurations of sculptural destiny. Whereas the painter is a literary, a story-telling type of thinker, the sculptor thinks primarily in terms of form. Whatever the ideas he may wish to express, these will have to be dealt with in the tight and compact materials and forms of sculpture. He has far less latitude in his potential choice of subject, and must often work in harsh and intractable substances. The sculptor's drawings must therefore conform to a more rigid and formal pattern than those of a painter, which are more loosely conceived and relatively informal: for painting is like a river, sculpture a mountain.

The drawings of a sculptor are of necessity less slovenly and wasteful than those of a painter, because he is always preparing for sculptural projects, and the whole direction of his drawing will be orientated and compassed to this end. He has no time to waste, for the pursuit of sculpture is tough and exacting, and in physical terms its demands are high. I hope that each of the sculptors included in this study will serve as an illustration of this thesis. Certainly all the great masters can be seen to conform to this austere and demanding pattern. Sculptors who are not in the top flight—such as Epstein—tend to produce drawings that have no specific or potent bearing upon the making of their sculpture. Epstein, by instinct a modeller rather than a carver, thought like a painter, and would surely have made a better painter than he did a sculptor. His range of subject interests, from nudes to flowers, from landscape to bible stories, was too wide and fragmented for movement along the narrow and stony path which the sculptor must tread. He possessed none of that single-mindedness of direction and purpose which marks the work of the true sculptor.

The reproductions in this book have been selected to demonstrate not only how single-minded is the drive of sculptural drawing, but also how the drawings of the natural sculptor, from Verrocchio to the masters and innovators of our own time, are a continual striving towards the simplest volumes of the round, and towards the relationship between the forms of the round and the nature of the space in which these forms have their being. To this end, as I think we shall see, the practice of drawing among sculptors is a closely knit and integral factor, permitting at the highest level no margin for the wastage and frivolousness that so often distinguishes the drawing of the painter.

MERVYN LEVY

ANDREA DEL VERROCCHIO

(1435-88)

ALTHOUGH THE common verdict on Verrocchio is that his chief importance in the history of art was his influence upon his pupils Leonardo da Vinci and Lorenzo di Credi, one much more important fact is invariably overlooked. Verrocchio was among the first of the 'new men' of Renaissance art, and certainly the most important pioneering sculptor and draughtsman of *movement*. Only his contemporary Antonio Pollaiuolo (1433–98), goldsmith, painter, sculptor, engraver and designer of textiles need be considered a figure of more or less equal importance among the early masters of the evolving Renaissance culture. In Renaissance terms, the complete man, the 'whole man', was of necessity many things, and the 'new man' the exemplification of an attitude to the arts which has since declined through the long avenues of increasing specialization. Today, the complete man is only one thing; a painter, an architect, a scientist. But long before the days of specialization the artist was a man for all seasons. The concept of painter *or* sculptor, goldsmith *or* architect, did not apply to such masters as Leonardo, Michelangelo, Cellini or Verrocchio, who was also a goldsmith, and even works of architecture are recorded in his early years. Verrocchio's works in the round, though small in number, are of the utmost importance as a series of vital landmarks in the evolution of the theme of movement in sculpture. Three masterpieces describe this objective. The *Putto with Dolphin* in Florence, *Bartolommeo Colleoni on Horseback* in Venice and the *Christ and Doubting Thomas* (**10**) in Florence. Of these three works I have chosen as my chief illustration the last because, crackling with vitality, rhythm and movement, it relates so closely to the artist's drawings. The raised arm of the Christ is not a fixture but a phase of the continuous action which is taking the arm in a living arc from the side of the figure to a point above the head. The energy of this movement flickers out into the fingers. Similarly, the hands of Thomas are alive and moving, they exist in a state of nervous action. Even the draperies possess animation, responding in their own movement to the life of the figures.

Verrocchio's drawings, too, bristle with action. They embrace a wide variety of activities: figures and animals in movement (**9**): the dynamics of muscular tension and relaxation (**1, 4**); the 'action' of social communication between two persons meeting and beginning to exchange conversation (**9**). The whole ethos of Renaissance anatomy is here broached, if not with the overwhelming surge and surety of Michelangelo's passion, at least with a pioneering zeal and a sharp eye. Indeed, the male figure in the *Study for a Hercules and putti* (**1**) is an anatomical summary of immense subtlety. One can calculate from such drawings how central was the study of anatomy to the creation of the whole work of art. In the *Christ and Doubting Thomas* one can *feel*—it is an empathetic communication—the anatomy of the figures conditioning the shapes and folds, the tugs and stresses and limpnesses of the draperies. And if we look at the *Tabernacle* (**2**), though more stilted and primitive in

style, we can see, nonetheless, precisely how a Renaissance sculptor, the whole man in fact, could think. The relationship of figures and architecture is the central theme of Renaissance aesthetics. Man is still seen in relation to buildings rather than to landscape. In this respect human and architectural anatomies are synonymous. The *Tabernacle* is also a pointer to the *Christ and Doubting Thomas*. It is essentially a sculptor's drawing, intricate yet simple, moving at all points through complexity to a distillation of homogeneous units. It is a quality evident no less in the painting of Verrocchio. Sculptural thinking, in essence the reduction of complex raw material to simple masses, is apparent in such works as the master's *Madonna and Child* (Kaiser Freidrich Museum, Berlin), his *Madonna adoring the Child* (Ruskin Museum, Oxford), and in the *Baptism of Christ* (Uffizi, Florence) which he painted in collaboration with Leonardo. In each of these works the conception is sculptural. Complexity is reduced to a minimum and the main elements are conceived as clear-cut units, detached from, rather than organically related to, the settings. Here are the roots of modern sculptural thinking; the divorce of simple figures from the clogging mass of extraneous data of which only the painter makes any use. Looked at in context it is a step of the greatest importance and originality, since one needs to remember that the whole course of medieval sculptural thought had been for a millenium inextricably interwoven with the patterns of architecture.

ANDREA DEL
VERROCCHIO (1435–88)

If we look at the drawings of Verrocchio (**5, 8**) it is, of course, easy to relate him to his pupil Leonardo. The main point of any comparison between the two masters, however, is the revelation of the purely sculptural in da Vinci. The clean, simply and softly modelled forms of Verrocchio are echoed later in the work of his pupil who, like his master, had been conditioned to see and think in sculptural terms. True, the genius of Leonardo was to outstrip by far the relatively limited potential of his tutor, but Verrocchio remains in some ways the more important figure. He was after all a pioneer, a first-timer. Had Leonardo's genius been less extensive, less wide-ranging, he would surely have devoted himself to the pursuit of sculpture. Michelangelo is perhaps the only true dual painter-sculptor in the history of Western art, for he alone works naturally, and with consummate genius, either in the solitary masses and units of sculpture, or in the intricacies of the painter's world.

But the phenomenon of the many-sided practitioner of the arts is both the strength and the limitation of Renaissance culture. Too civilized and too cultivated by half, the genius of the *Cinquecento* is always perilously close to a classy and stylish dilettantism. With Pollaiuolo, Cellini and Verrocchio this brilliant virtuosity operates at the second level of genius; with Leonardo and Michelangelo at the highest. Yet it is in the work of the lesser masters that we can best study the spirit of the time and the nature of the changes that were then taking place. In their thirst for knowledge, in their eagerness to explore and practise in a variety of directions, it is the pioneers who reveal—as in Verrocchio's *Study for David* (**3**), which in spite of its anatomical documentation remains a primitive drawing—the true nature of change. Here is change in being; not in the final solutions of the great masters wherein the roots and causes and appearances of change have been at last resolved and ironed out so that we can no longer witness the machinery of metamorphosis. Here is change when the need for change first arises. Thus, the drawing of *David* is a watershed separating medieval primitivism from the full flower and glory of the High Renaissance aesthetic in which the flat is finally overpowered by the round. It is also a purely sculptural drawing, pointing the way into that long, still shadowy avenue of organic modelling and carving which was to reach its apogee in Rodin.

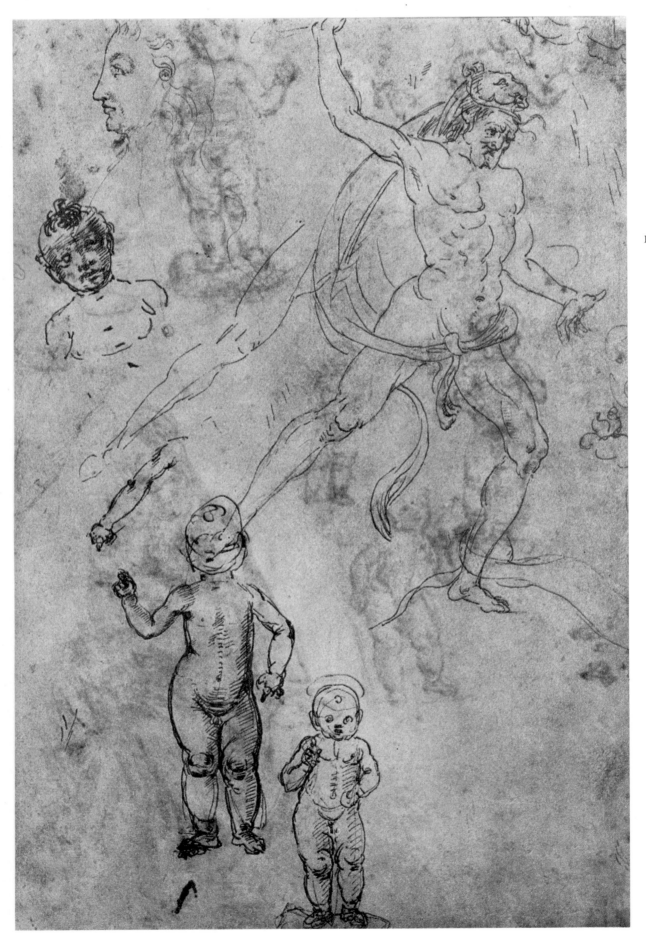

1 Study for a Hercules
and putti. *Pen and ink*

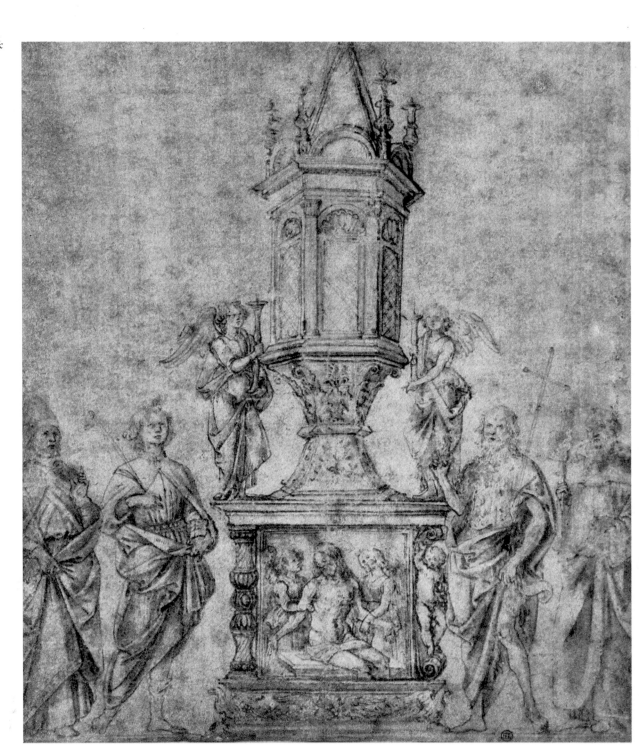

2 Tabernacle. *Chalk*

13

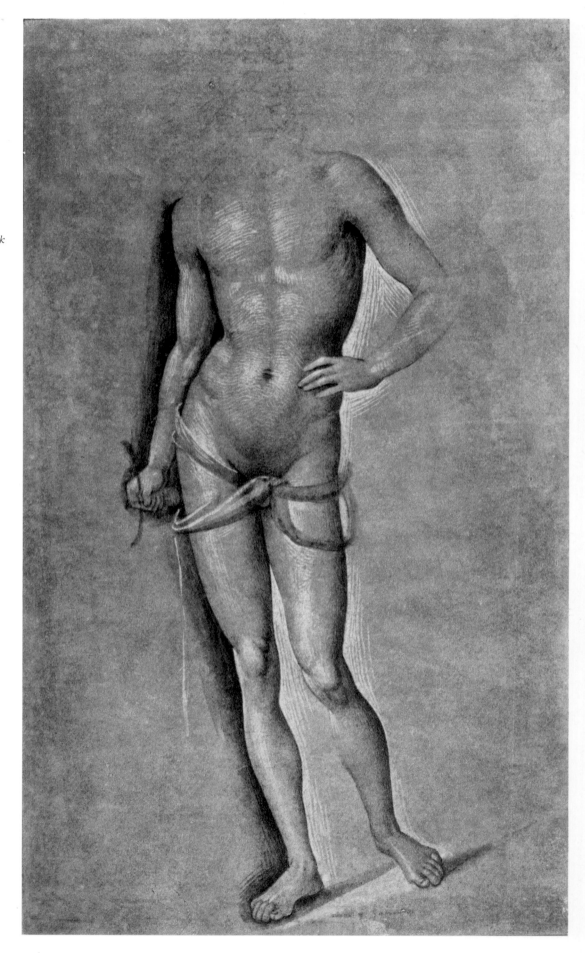

3 Study for 'David' *Black and white chalk*

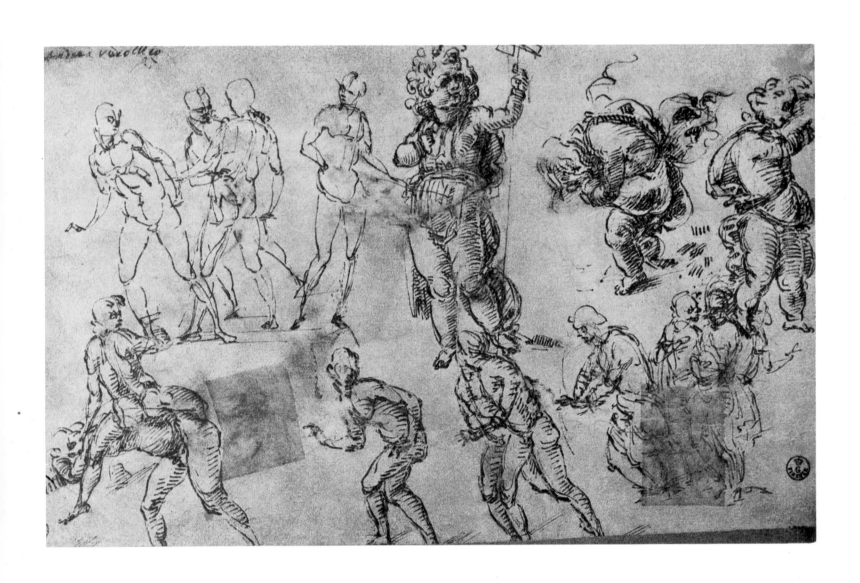

4 Sketches of various figures and putti. *Pen and ink*

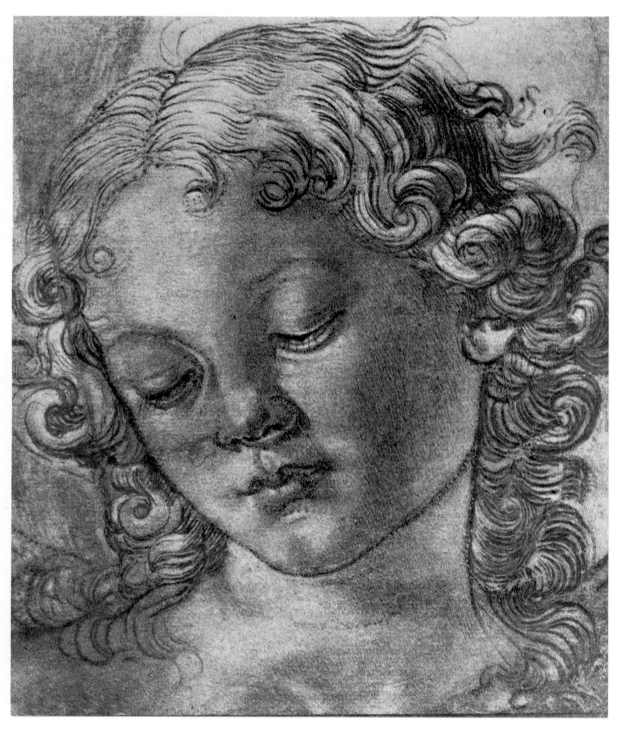

DATO
NICHO
LO

17

7 Study for Madonna and
Child. *Pen and wash*

8 Head of a woman. *Chalk*

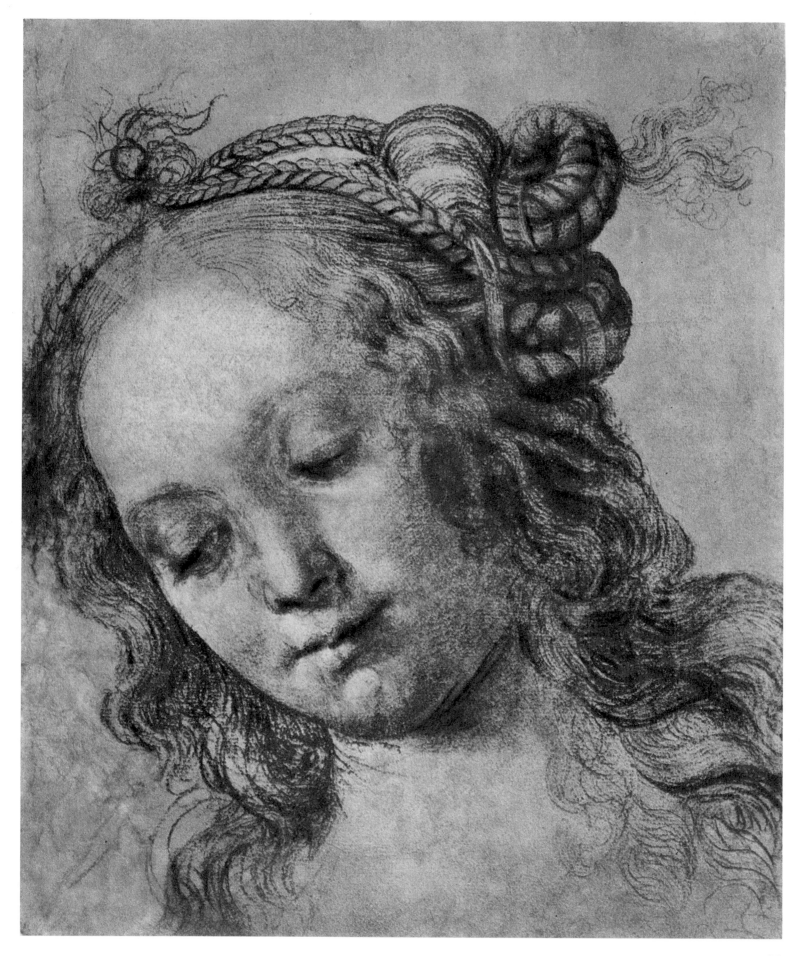

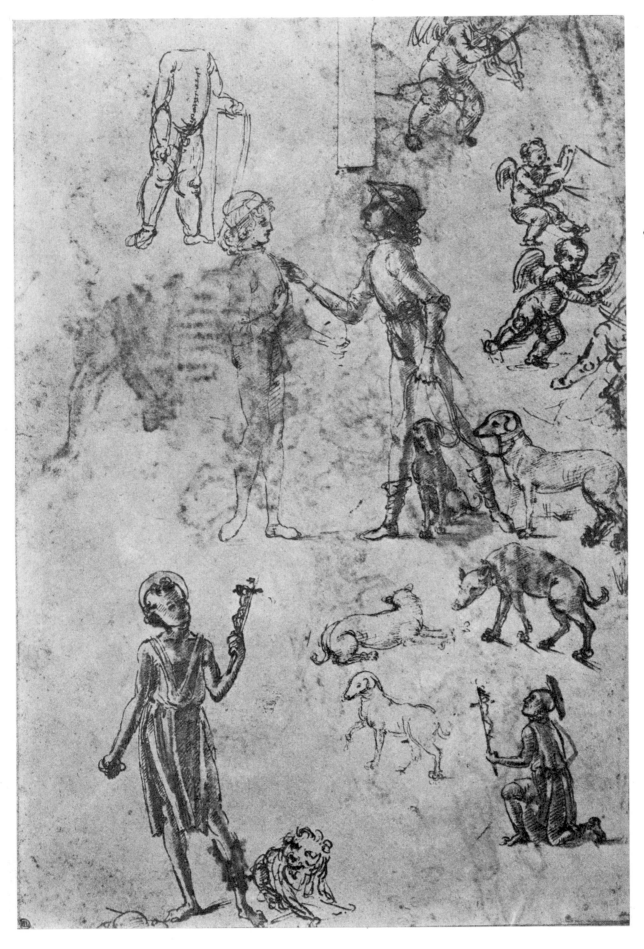

9 Study for 'St Jerome
 and Angels'. *Pen and wash*

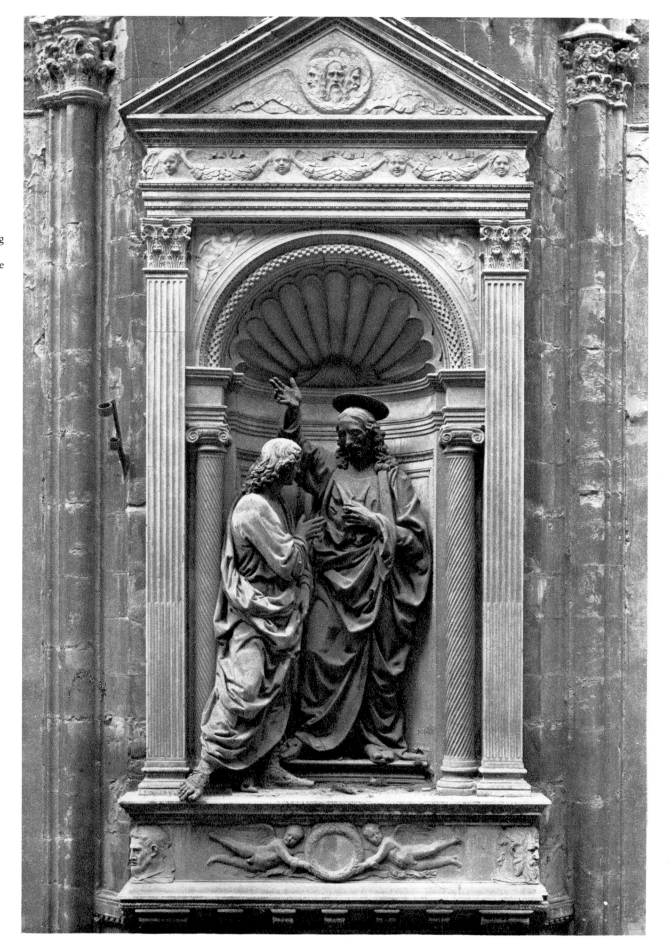

10 Christ and Doubting
Thomas, Church of
St Michael, Florence

MICHELANGELO

(1475 - 1564)

MICHELANGELO'S GREATEST achievements were those works (not the best known or popularly the most celebrated) which the ignorant would call 'unfinished', and the enlightened 'organic'. That is to say, modellings, carvings and drawings, which retain the aspect of a continuous coming into being. In Michelangelo the journey is always better than the arrival. If we look at the drawing of *St Anne, the Virgin and the Infant Christ* (12), or at the tiny wax sketch of a *Slave* (11), the point is made. Michelangelo was a genius of the rarest kind; one who, in spite of the length of his working life, continued to evolve and grow, so that a conception such as the Pietà on which he was working between the years 1548 and 1555 displays a vigour and a sense of continuous becoming which were foreshadowed in many of his earlier carvings. Even as late as 1564, the year of his death, the *Rondanini Pietà* is alive with the energy of his characteristically open and organic chiselling.

The modelling style of the little waxen giant, the fresh, suggestive pen-work of the drawing of St Anne, and the living style of his late carving, all display this sense of growth. Michelangelo's *oeuvre* can be divided into two distinct categories. On the one hand there are the galaxies of meticulous and searching anatomical drawings, exercises and studies of immense diversity matched, in his more 'polished' and 'finished' carvings by such works as *David* and *The Dying Slave*, and by the tremendous anatomical symphonies of the Sistine paintings. On the other hand, there are the evolving drawings and carvings of which I have already spoken. The former category, although it includes most of the masterpieces which are usually thought of as the artist's supreme achievements—the 'finished' carvings in particular—seems really to have been a process of elaborate preparation for those works which fall into the second category. At a time when the study of anatomy was an exploratory adventure comparable in its time with the analyses of Cubism in ours, it was inevitable that the painters and sculptors most keenly and intelligently involved in this investigation should concentrate upon, and in so doing frequently over-emphasise, the skeletal and muscular construction of the body. Even so, for all their obsessive concentration upon anatomical detail, Michelangelo's drawings of the figure, especially those worked in pen and ink, display an unmistakable conception and style which perfectly complements the conception and style of his open, continuous carving. In such drawings as the *Study of a Nude Torso and Various Heads* (19) and the *Studies from the Nude* (18)—reproduced the same size as the original drawings—the open style of the penmanship parallels the style of open chiselling which Michelangelo frequently employed. The rough-cut marks of the chisel are already endemic in the vigorous, broad style of the pen. Drawings such as this, or the *Study of a Horse* (20), are not only anatomical explorations, but virile prefigurations of the nature of the sculptor's greatest style of carving. The two sheets of studies just

referred to, as well as the drawing of St Anne, were all executed about 1501, when the artist was still a young man, and can be seen therefore as excellent illustrations of the thesis that the drawings of sculptors, even the earliest (as also for instance the early drawings of Henry Moore) inevitably suggest the continuing direction of the artist's sculptural destiny.

Michelangelo's earliest pen drawings can be closely related even to the latest of his carvings, and certainly to the style of such masterpieces of open carving as the *Captives* from the Boboli Gardens. In the carving itself one can study the marks of the claw chisel which bear a clear affinity with the hatching of the pen drawings. Only in his early work did Michelangelo make extensive use of the auger. Elsewhere it is usually the punch and claw chisel that determine the character of his carving and, by their nature, impart to his work the rough-hewn quality which is so readily comparable with his penmanship. The vast brooding might which pervades the artist's main work is also implicit in his drawings, especially those heavily worked studies in red and black chalk such as *The Resurrection* (**17**) and the *Bacchanal of Children* (**16**). These are not only magnificent expressions of anatomical knowledge, but drawings in which the artist realises one of the primary objectives of sculpture; the agitation of space by the opposition of forms. This applies to all sculptors of action. So far as this study is concerned, Rodin, Kneale and Calder are sculptors of action. On the contrary, sculptors of repose such as Moore, Hepworth, or Arp, set their forms in areas of serene, unmolested space. Their artifacts are ships becalmed. But Michelangelo, master of storm and tempest, is continually obsessed with the problem of agitating space; with the need to set his forms heaving, pulling, thrusting and plunging. His quest is a continuous and restless thirsting for knowledge (the consolidation of anatomical data), for the dynamic of forms in action, and for the realization of volume and monumentality. *The Male Nude with Proportions* (**15**) is a classic example of the artist's preoccupation with anatomy. This relentless search permeates the whole of his *oeuvre*, imparting to the female figure, no less than the male, an obsession which is almost always top-heavy. It was a cross he bore nobly, but heavily. Less elegant by far than Leonardo or Raphael, and preferable only to the jittery anatomies of Tintoretto, Michelangelo's morose and brooding universe of bone and muscle, tendon and cartilege, is the expression of the destiny of man's earthly form; the tedium of the flesh. Nowhere else in the patterns of Western art is the soul so bedevilled by the body.

The new science of anatomy was a hard task-master. Yet overwhelming as Michelangelo's view of anatomy was, he extracted from its study not only a new conspectus of scientific data, but an intensity of volume and a vision of the monumentality of action which only Rodin has paralleled. His drawings are the key to all the mysteries of his art.

MICHELANGELO
(1475–1564)

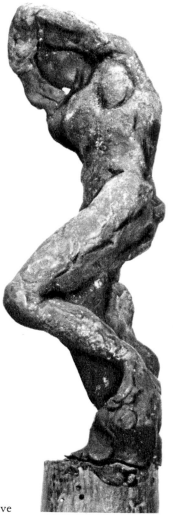

11 Wax sketch for an unfinished marble statue of a young slave

23

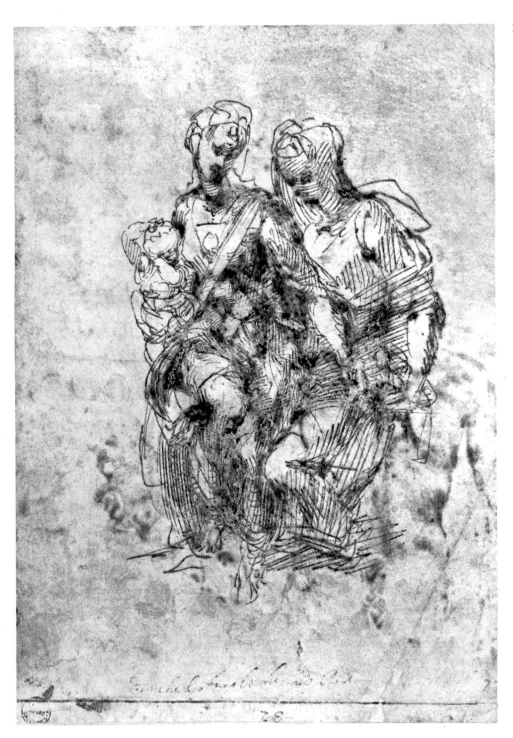

12 St Anne, Virgin and the Infant Christ. *Pen and ink*

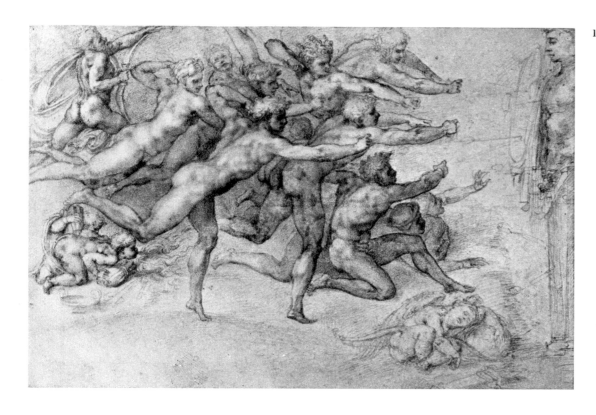

13 The gods shooting at a Herm.
Red chalk

14 Tityus. *Black chalk*

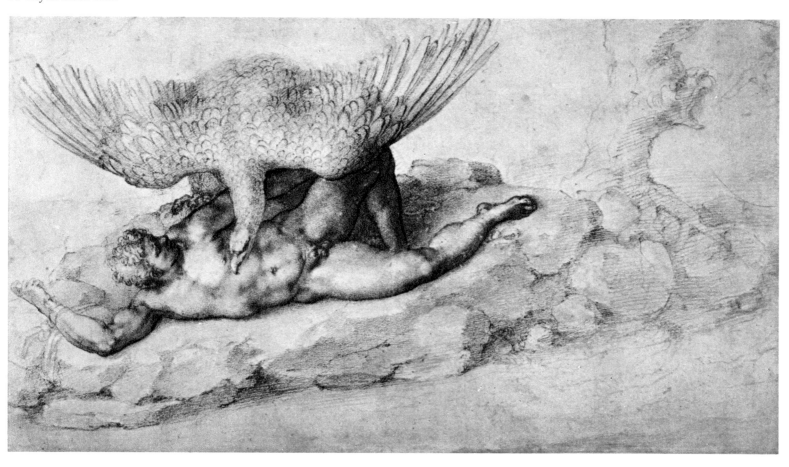

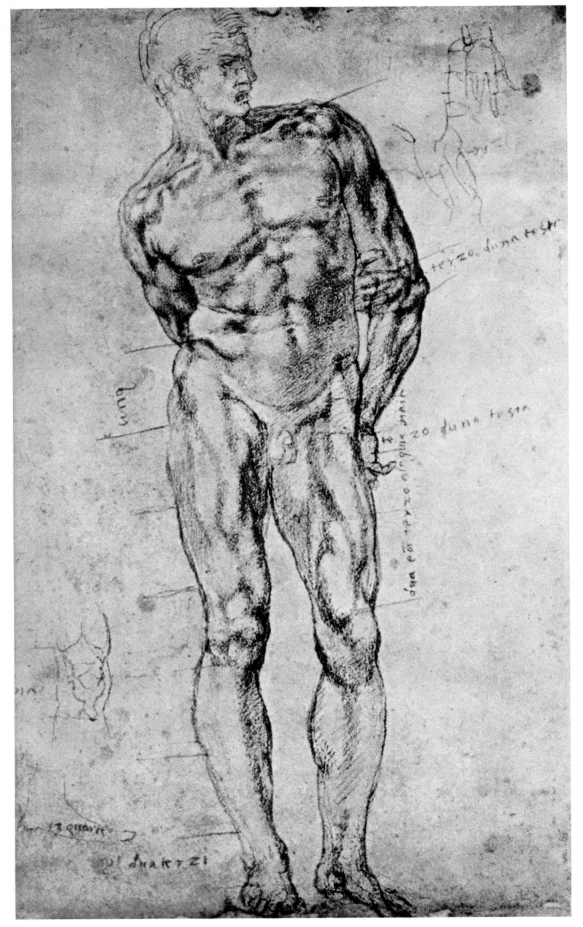

15 Male nude with proportions.
Red chalk

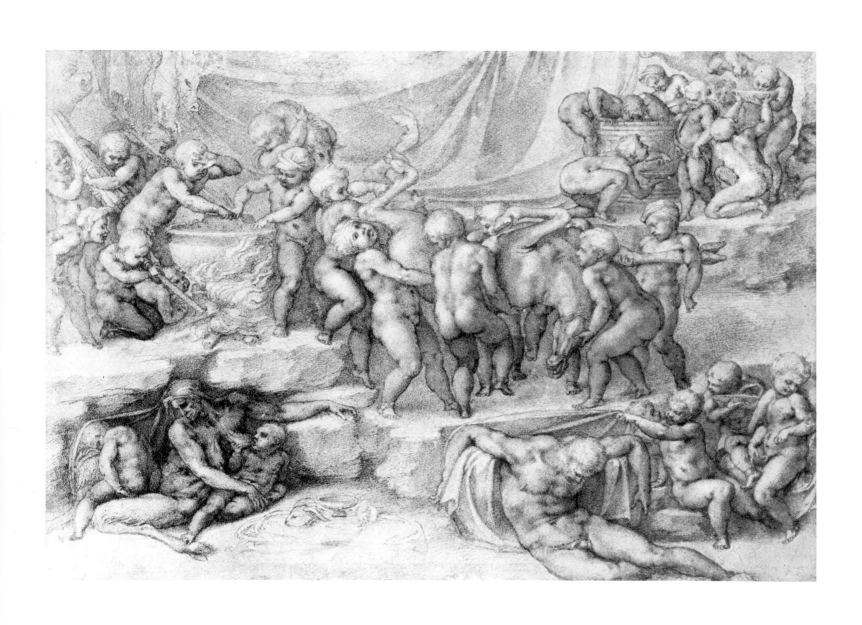

16 Bacchanal of Children. *Red chalk*

17 The Resurrection. *Black chalk*

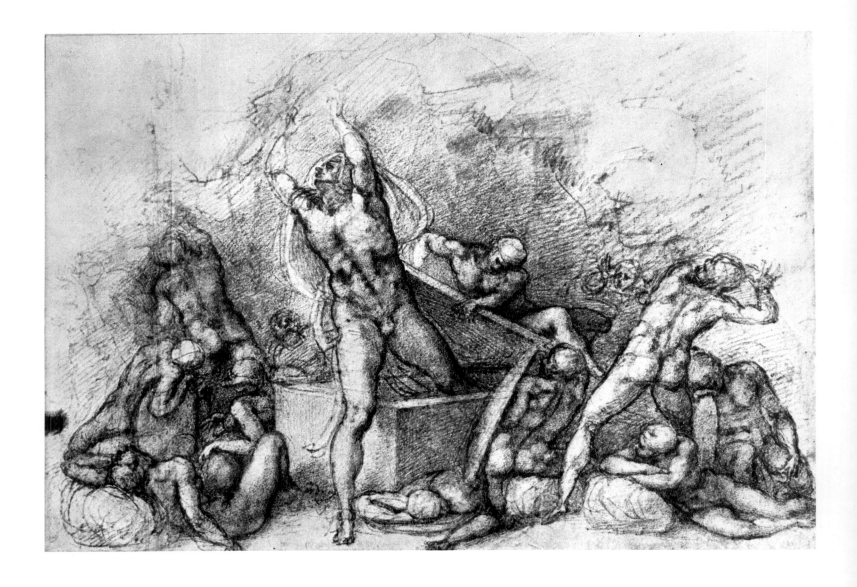

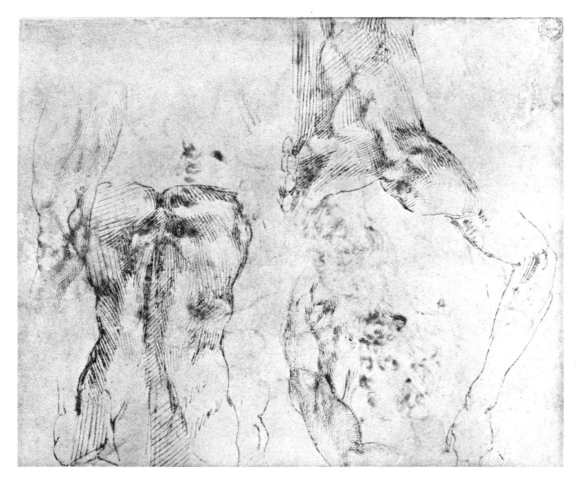

18 Studies from the nude. *Pen and ink*

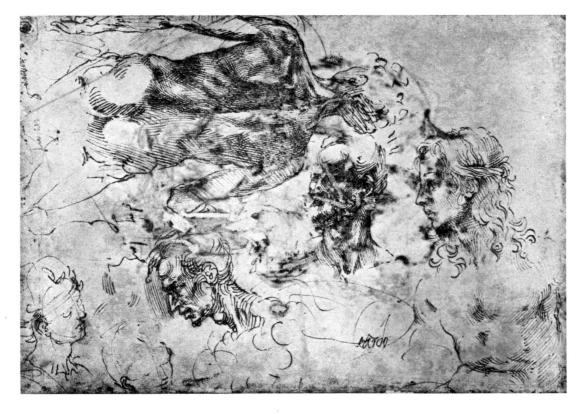

19 Study of a nude torso and various heads. *Pen and ink*

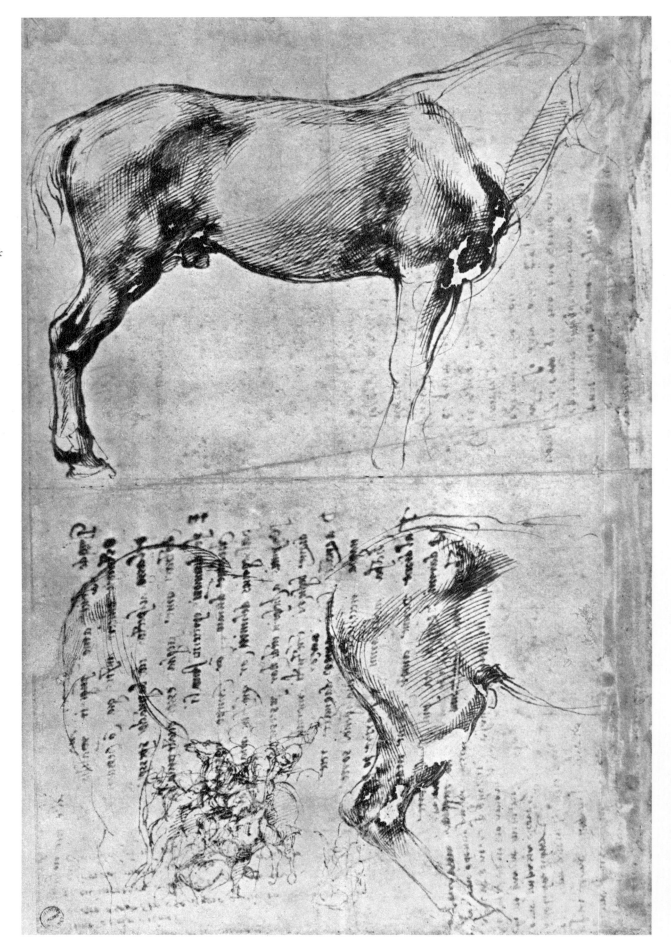

20 Study of a horse
(detail). *Pen and ink*

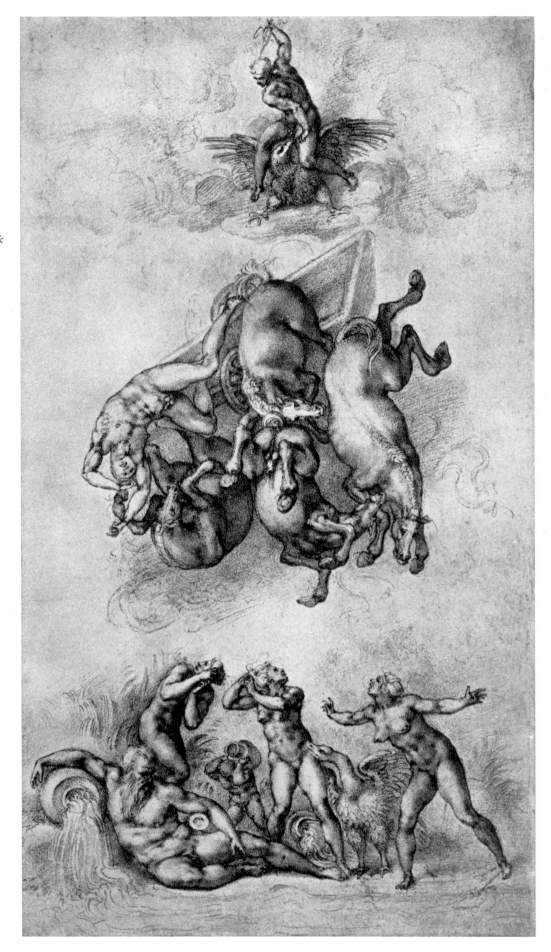

21 The Fall of Phäeton. *Black chalk*

GIOVANNI LORENZO BERNINI

(1598 - 1680)

MICHELANGELO'S PRIMARY contribution to the patterns of European sculpture was his development of High Renaissance Classicism and its subsequent influence upon the emergence of the Mannerist style in the second half of the Cinquecento. This led in turn to the empty, rhetorical posturing of the eclectic manner, and it is not until the Baroque style emerges in the seventeenth century that we are once more in the presence of an aesthetic which lives and grows from within—from an authentic core of energy and vision. The Baroque style is distinguished by its living rejection of the thesis of ideal classicism and its insistence on the validity of emotion and sensuality as fundamental elements in the creation of a new, dramatic realism. Molesworth describes this quality very neatly in his study *European Sculpture*: 'To the modern observer Bernini's figure of *St Theresa*, as it were frozen into marble at the climax of a self-induced orgasm, is acutely embarrassing, but to the seventeenth century such a triumph of realism was perfectly valid in that it inspired the observer to share in the ecstasy of the saint. This sensuality runs right through the century, even after the second quarter when classicism begins to reassert itself.'

Herein lies the essential difference between the art of the High Renaissance and that of the Baroque. The one is a static, 'idealized' form; the other a dynamic activation, fully intended to inspire in the spectator sensations of ecstasy and exaltation, of heightened awareness and intensified perceptivity, according to the subject. Religious ecstasy on the one hand or—as in the case of Bernini's statue of *Constantine the Great* (**22**), which I have included as a characteristic example of the sculptor's genius—the emotive intensification of history and legend. The sense of ecstasy is the same: Theresa's orgasmic beatitude, or Constantine's vision of conquest and power. We can sweat it out with both. In choosing Bernini's *Constantine* I have resisted the obvious. The *Ecstasy of St Theresa*, so often highlighted—and rightly—as a quintessential masterpiece of the High Baroque, tends to obscure a fundamental aspect of the old master sculptor's role; his 'ordinariness'. By this I mean his primary function as a designer of public monuments. St Theresa is too often thought of and written about in isolation. No such false 'glamour' attaches to Bernini's *Constantine*, or to the selection of drawings which I have used to demonstrate the everydayness of the master's working methods, their relationship to the evolution of his sculptural destiny, the intensity of their inevitable single-mindedness, and their perfect exposition of the Baroque spirit. At many points they both illuminate and complement, and are themselves illuminated by, the characteristics and qualities of the sculpture. Bernini's use of draperies as a basic element in his vocabulary of expression is to be seen both in the painted stucco background to the statue of Constantine, and in such working drawings as the studies of angels for the altar in the Chapel of the Holy Sacrament in St Peter's (**24** and **27**); as it is in the *Design of a Mirror for*

Queen Christina of Sweden (**23**), which illustrates the figure of Time drawing aside a curtain to reveal in the mirror the decay of youth and beauty. Again, in the working drawing for the Altar of the Fonesca Chapel at S. Lorenzo in Lucina (**29**) the exuberant flow of draperies add to the rhythm of wings and the dramatic attitude of the figures in joyful and vigorous acclamation of the Counter Reformation's revolt against the controlled classicism of the Renaissance.

A rare glimpse of Bernini's working method is provided by *The Angel with the Crown of Thorns* (**31**). Here we can glimpse the creative germ of his aesthetic from its first, tentative notation. And if we take the more or less literal meaning of the term Baroque (*barroco*, Portuguese) as one which describes the character of the large, rough, irregular pearl commonly used in the florid jewellery of the period, it is not difficult to see why this designation is applicable to the aesthetic expressions of the age—architecture, sculpture, painting. This becomes apparent if we look at Bernini's drawing for the *Fontana del Moro* (**30**) or at his studies for a *Fountain of Neptune* (**25, 26**). That he should also have been so conscious of the significance of the rhythms and convolutions of water as an intrinsic element in the overall picture of his conceptions in this vein shows how fully the Baroque manner made use of natural drama (the play of light and shadow, the swirl of draperies, the flow of hair, the movement of water) to intensify its impact. One might say that in these brisk crescendos of light and shade, of tumultuous movement and flashing action—all calculated as part of the whole design—the sculptor had ensured those characteristic emotional climaxes of which *The Ecstasy of St Theresa* is but a single manifestation.

If Bernini fails, it is in those pallid and mediocre drawings such as the *Self-Portrait* (**28**), or the drawing of Cardinal Scipione Borghese (the sculptured portrait is something quite different) which in themselves bear no relation to the artist's primary function as a sculptor of the Baroque. Any departure from this crucial objective could lead only to the wasteland of a shallow and sterile mannerism. This fact in itself shows how little room for manoeuvre the sculptor enjoys when he surrenders himself to the painterly approach.

GIOVANNI LORENZO
BERNINI (1598–1680)

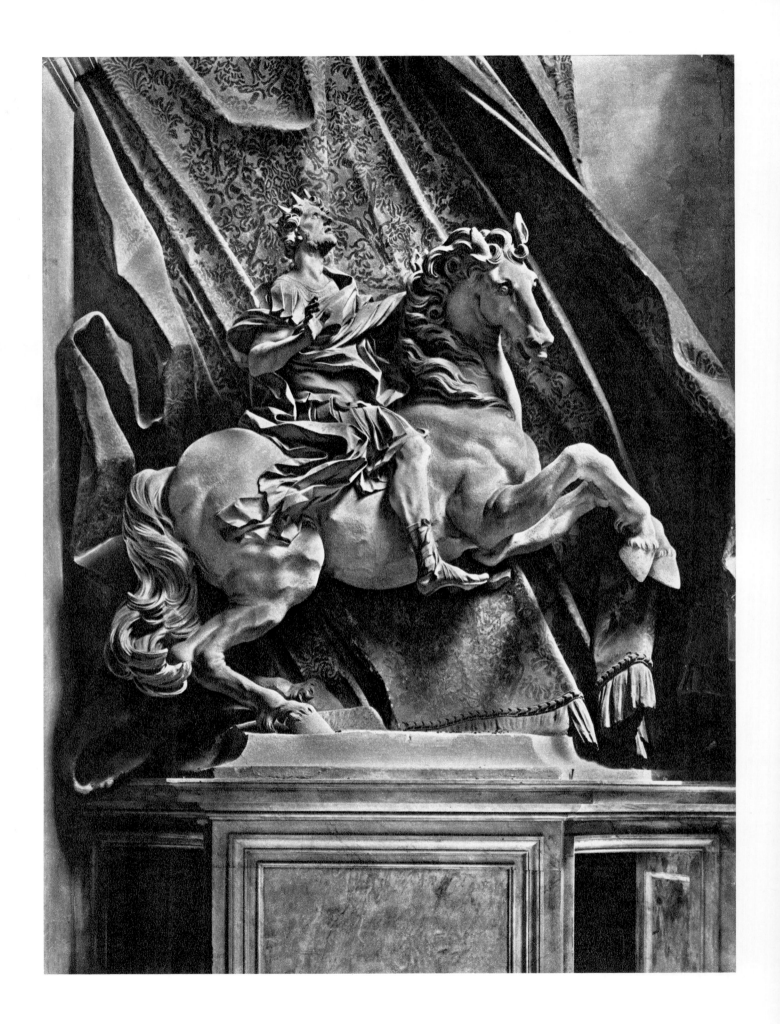

23 Design for a mirror for Queen
Christina of Sweden. *Pen and bistre
wash over black chalk*

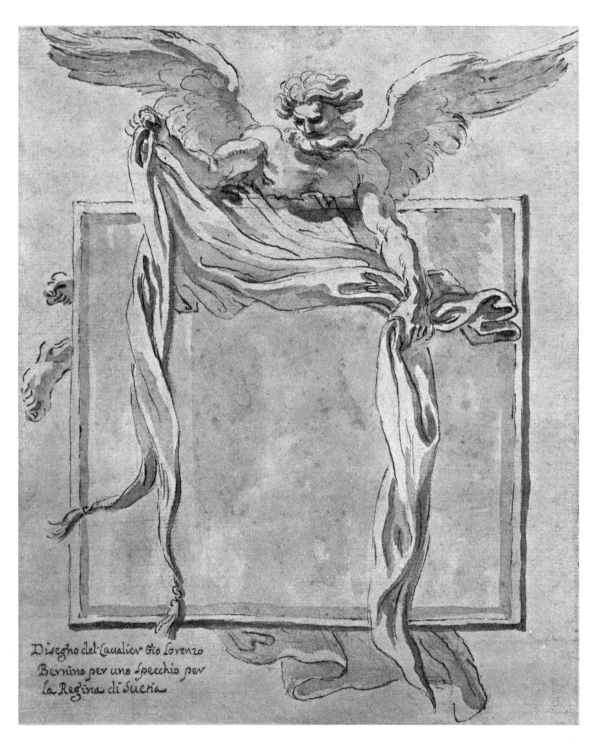

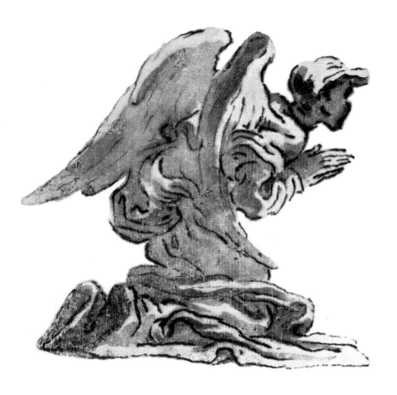

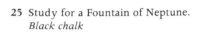
25 Study for a Fountain of Neptune.
Black chalk

24 Study for the altar in the Chapel of
the Holy Sacrament, St Peter's, Rome.
Pen and bistre over black chalk

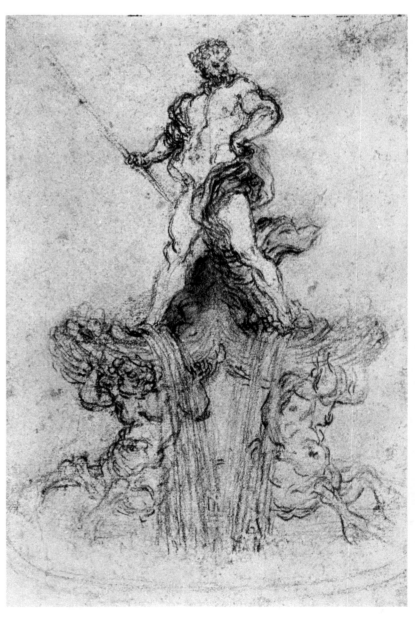

36

26 Study for a Fountain of Neptune.
Black chalk

27 Study for the altar in the Chapel of
the Holy Sacrament, St Peter's, Rome.
Black chalk and bistre wash

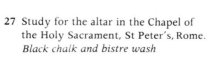

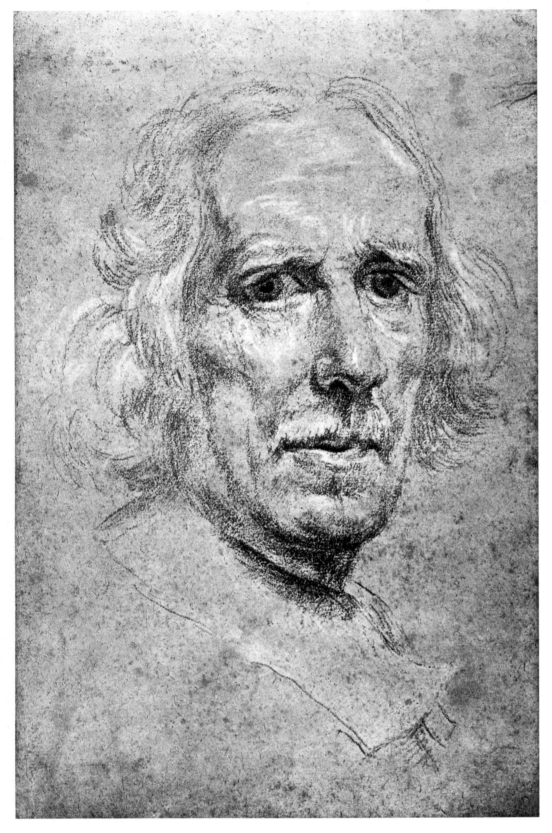

28 Self Portrait. *Black chalk*

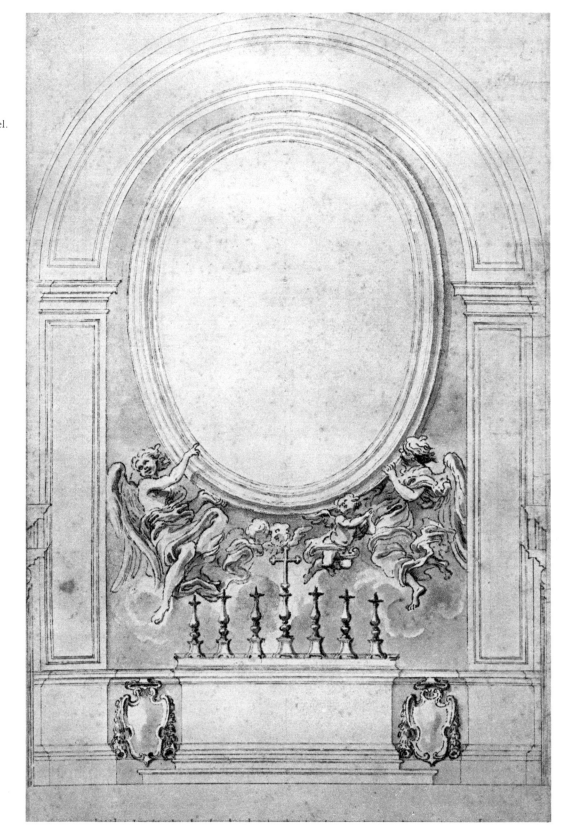

29 Study for the altar of the Fonesca Chapel.
Pen and bistre wash over black chalk

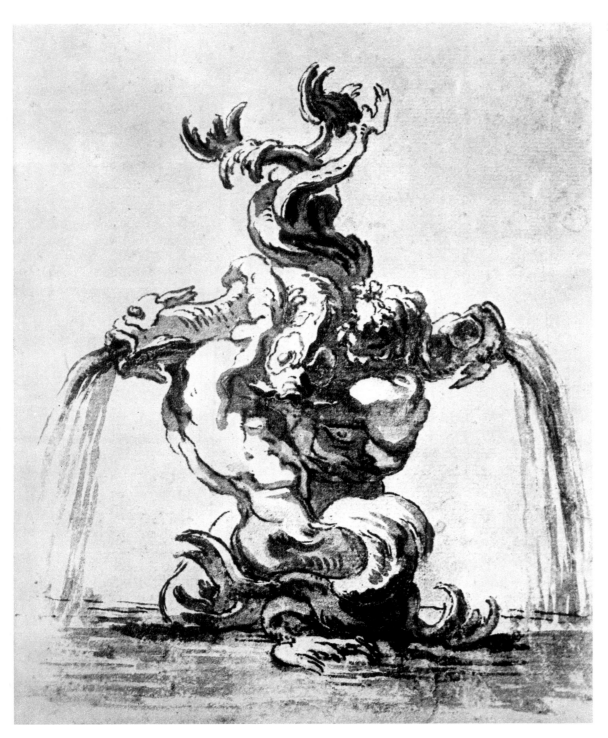

30 Study for the Fontana del Moro,
Piazza Navona, Rome.
Pen and wash

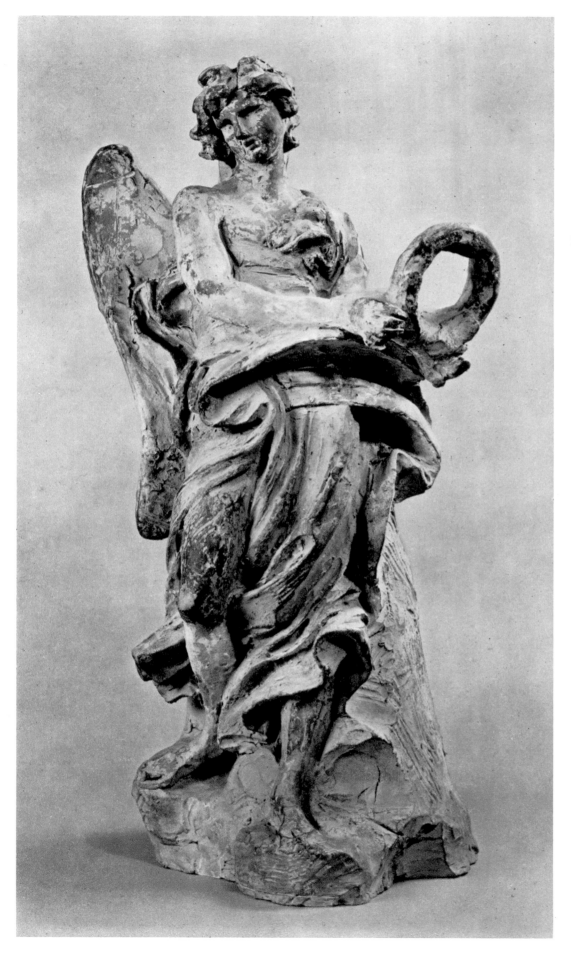

31 Angel holding the Crown of
 Thorns. *Clay, height* $17\frac{1}{2}$ *in.*

ANTONIO CANOVA

(1757 - 1822)

OUR JUDGEMENT of the minor figures in the history of art is often downright blind. Sculptors who suffer in particular are those associated with the neo-classical movement, and although the names of some of the neo-classical sculptors rank fairly highly, such as Clodion in France and Flaxman in England, that of Antonio Canova is one of the most frequently underated and neglected. Yet as a sculptor-draughtsman his art reveals at many points a vigour, a freedom, and a capacity for invention far ahead of the obvious constructions of the neo-classical idiom seen purely as an academic phenomenon. A drawing like the *Seated Woman* for instance (32) is a remarkable portent of a vision and style closer to that of Maillol—or Moore even—than to the sterile naturalism characteristic of the period. As a sculptural conception, executed with a breadth of treatment that suggests an artist of the twentieth century rather than one working in the second half of the eighteenth, it shows very clearly how profoundly the intuitive demands of sculptural thinking (and by this I mean the artist thinking *through* drawing towards a plastic objective) can determine the nature of drawing. This solitary study stands alone and out of time as a remarkable example of the grass roots of the sculptor's approach to his problems. In many ways, and especially in its massive formalization, it echoes and resembles certain forms of primitive sculpture. It indicates that formal, as opposed to literary, thought is less circumscribed by the local character of time and place.

If we study the drawings of Canova, detaching them from the context of the most debased interpretation of neo-classicism—that it merely added saccharin to the rediscovery of antiquity or, looked at another way, filleted away the bones of the genuine classic style—he can be seen as an artist seeking to distil from nature a conception of form every bit as pure as that sought, however differently, by Maillol and Moore. Canova was not in essence concerned with the classic manner, or with classical subjects, in the sense that is usually ascribed to him. His primary concern, it seems to me, was the thinking of form into a series of cleanly interlocking components. *The Three Graces* (43) bears a revealing comparison with Henry Moore's *Three Standing Figures* of 1947. It is only the titles, and the inevitable differences in 'local' (time-place) aesthetic conception which separate two such works; in almost all other respects they can be equated. The basic objective is to extract from nature a formal realisation of monumentality; the subject is simply a means to this end. But the subject is not the end. It is on this point that critics of Canova usually make their errors of judgement. But, as I say, it is to the sculptor's drawings that we must turn if we would apprehend the nature of his art, and witness the distinctive phenomenon which is implicit in all true sculptural drawing. Begin by considering the drawing *Tree Trunk* (33) and the study *Landscape with classical prospect* (34). The qualities and properties which distinguish the conception of the *Three Graces* are implicit

here. The central forms in both drawings—the tree trunk and the buildings—are realized in totality as massive, essentially simple elements. This seems to me perhaps the crucial test of sculpture. Subject ought always to be incidental to, and contained by the over-riding need to reduce the sculptural exercise to the simplest and most economical concept of the block—the mass—in opposition to the space in which it exists. All the Canova drawings which I use by way of illustration seem to me to demonstrate this idea. I stress again that one should discard the titles—the obfuscating subjectivity—of these studies in order to see them, and realize them, purely as notations for sculpture.

Some idea of the nature of certain misconceptions regarding Canova's art can be gathered from a contemporary observation set down by J. S. Memes, one of Canova's biographers (1825). This concerns not only his sculpture, but his drawing. 'It was his (Canova's) frequent exercise to draw, or more generally to model for several successive days, from the living subject. In thus diligently imitating, he never allowed his imagination in the slightest manner to deviate from nature . . .' This is not so. It is a slander perpetuated down to the present day by historians and critics who still consider all forms of the neo-classical as 'naturalistically imitative'. This may be true of some of the lesser neo-classicists, but it is not very discerning to dismiss Canova as a mere imitator, or to argue that his art reveals no degree of creative individuality. His drawings are often highly original, freely rendered, and genuinely inventive. Writing to Count Leopoldo Cicognara from Rome in February, 1815 Canova remarked: 'I have read that the ancients, when they had produced a sound, used to modulate it, heightening and lowering its pitch without departing from the rules of harmony. So must the artist do in working at the nude.'

For Canova the nude was the ultimate symbol—the cipher—through which all his ideas were expressed. In stressing 'the rules of harmony' he is proposing that the artist must of necessity operate within a circumscribed area of aesthetic activity and that if he does not, his work is chaos. One has only to consider the contemporary situation in all its grotesque and pitiful manifestations, both social and aesthetic, to see the truth of this argument. In its present death-throes the permissive-society culture is its own executioner. The term 'rules of harmony' is therefore a synonym for whatever the fundamental principle upon which an artist bases his work. Invariably this will have universal connotations. The concept of *universal dynamism* —the simultaneity of action ('Everything moves, everything runs, everything turns swiftly')—envisaged by Boccioni as the pivot of Futurism is no less a 'rule of harmony' than Canova's conversion of the conflicting forms of the nude from the disharmonies of action into the serenity of an 'ideal', harmonious repose. It is in the modulating, in the heightening and the lowering of the pitch of his theme—and this

ANTONIO CANOVA

(1757–1822)

ANTONIO CANOVA
(1757–1822)

involves the imagination—that we must look for points at which to assess the nature of Canova's inventiveness. If the theme-song is the nude, the notes are infinitely varied, though always in harmony. *The Three Graces* is not a hunk of slavish naturalism, but a subtly inventive relationship of modulated forms set in a correspondingly modulated space. The formalization of the draperies alone expresses an intuitive note of pure rhythm which in essence is no more literary than the rhythms of Jean Arp's *Madame Torso with Wavy Hat* (**73**). As a preparation for sculpture, look again at the drawings I have already indicated, and in particular now at the *Seated Woman* (**32**), the *Eleven Dancers* (**35**) and the *Sketch for 'The Graces'* (**37, 38**). The first of this group of drawings is not only a search for a simple and monumental analysis of the complexity of form, but also, in the double-head—a simultaneous view of full-face and profile—an ingenious attempt to analyse in what is essentially a sculptural idea, the successive phases of a movement around the sculptured figure. In this sense it is interesting to consider the double portraits of Picasso which themselves reveal a similar sculptural affinity. The *Eleven Dancers* is a startling and powerfully inventive attempt to extract from a pattern of movement the intrinsic blocks of monumental rhythm, to freeze them in their totality and, by this process, to strip action of its extraneous and disruptive elements so as to present only the residual harmony which is the root of all movement and all stillness. Here is the modulation, the heightening and the lowering of the pitch of his theme—without departing from the rules of harmony—which Canova reasoned was one of the primary functions of art.

The *Sketch for 'The Graces'* (**37**) is an equally remarkable study and a notable preparation for the demands of sculpture. Against the sheer monumental bulk of the detail in the foreground—a formal cleansing of extreme sensibility—the artist has endeavoured to see the whole group as a simple unit. The result is the realization *in toto*, or in element, that the function of sculpture is to extend the nature and aspect of mass by a dimunition of its superfluities. It also demonstrates that physical size is of no consequence in sculpture. The pebble is as significant as the boulder. And as massive.

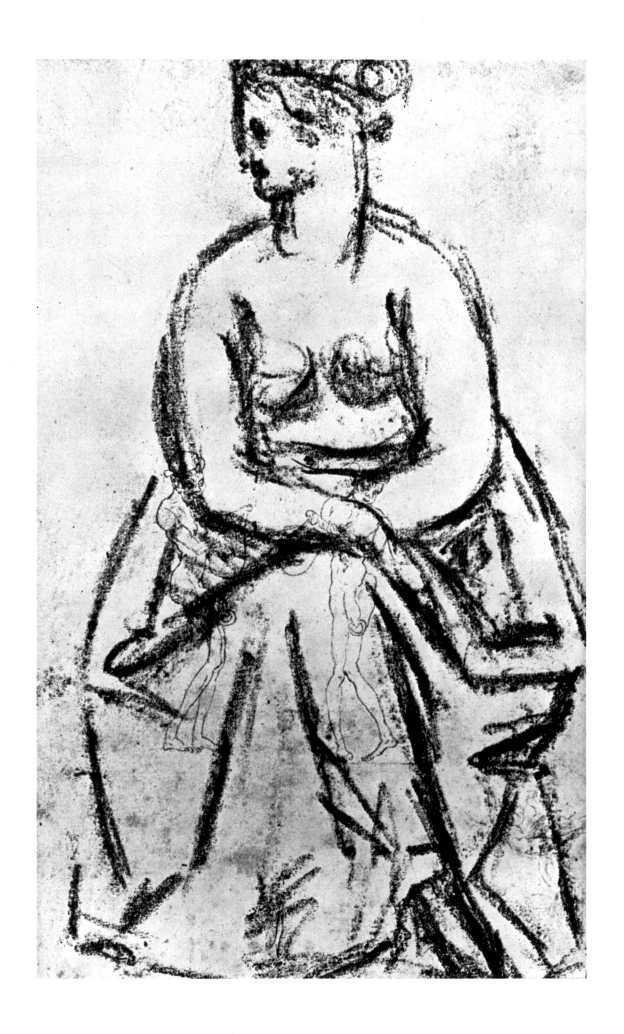

32 Seated woman. *Carbon*

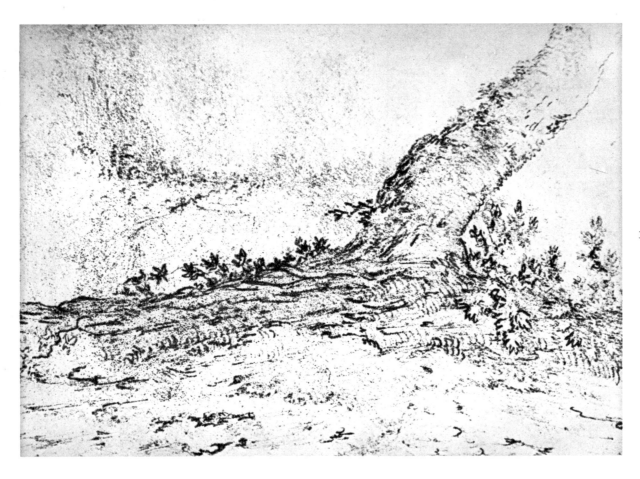

33 Tree trunk. *Chalk*

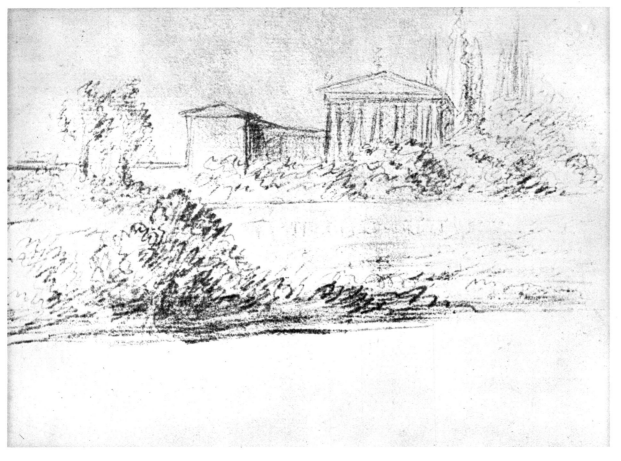

34 Landscape with classical
prospect. *Chalk*

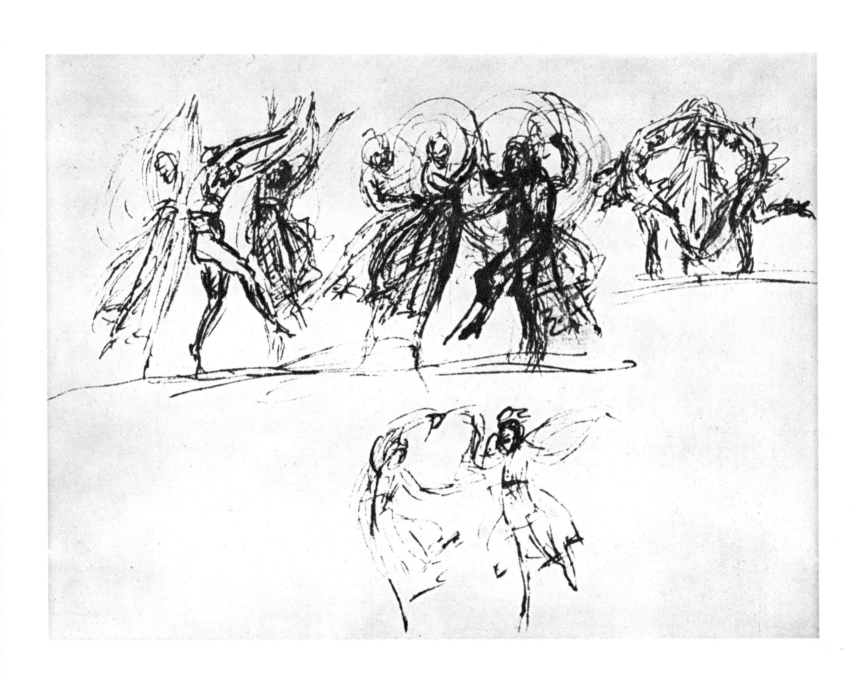

35 Eleven dancers. *Pen and ink*

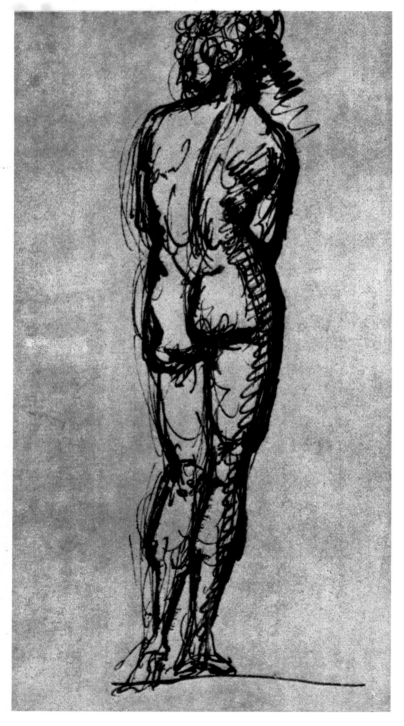

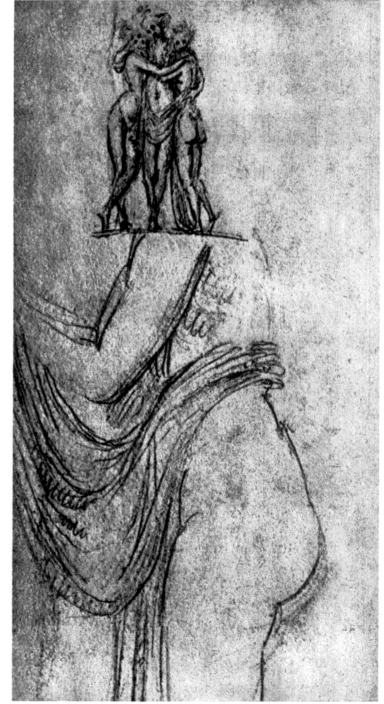

37 Sketch for 'The Graces'. *Chalk*

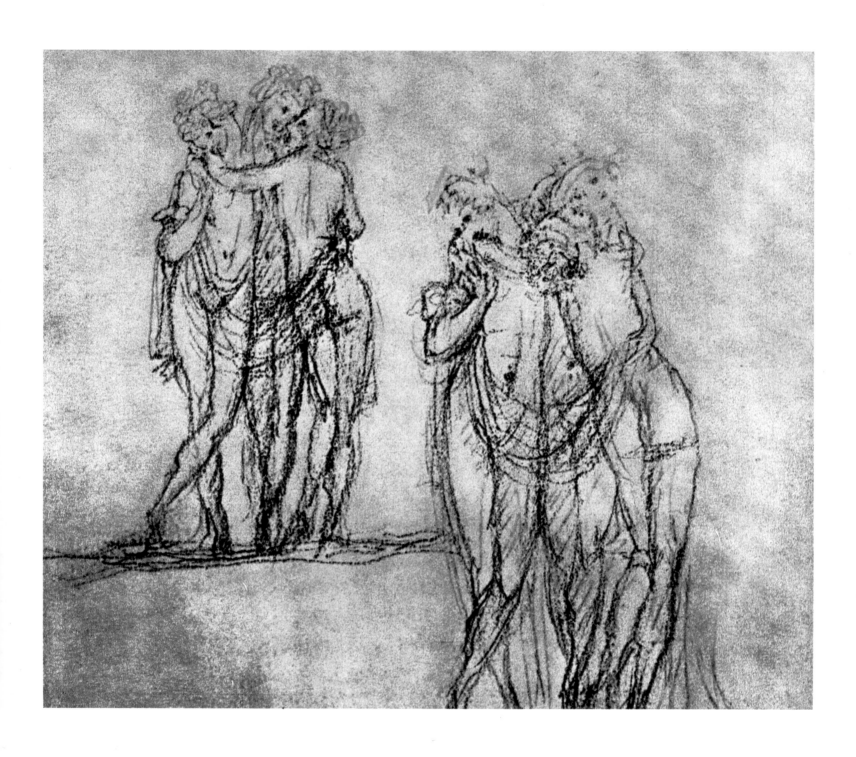

38 Sketch for 'The Graces'. *Chalk*

39 Study for 'Venus and Adonis'.
Pastel

40 Sketch for 'Cupid and Psyche'.
Carbon

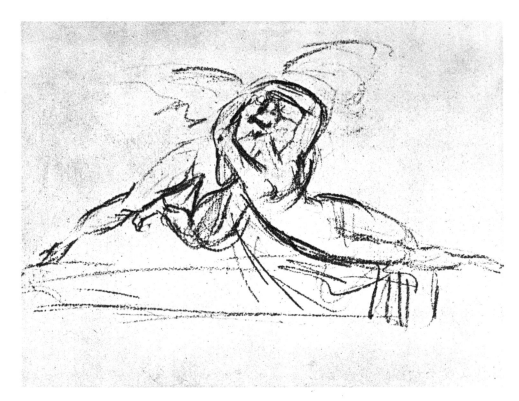

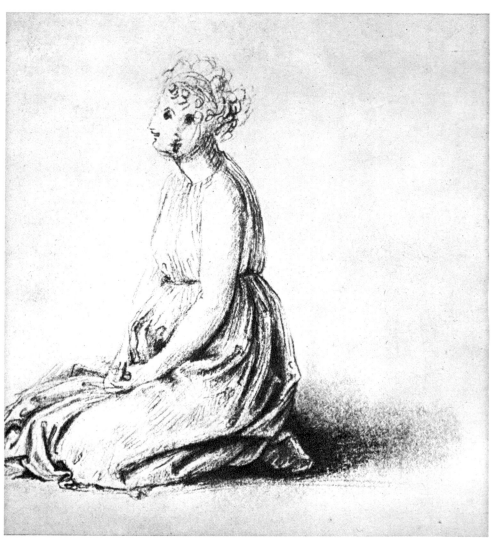

41 Study of a seated woman showing
profile and full face. *Chalk*

51

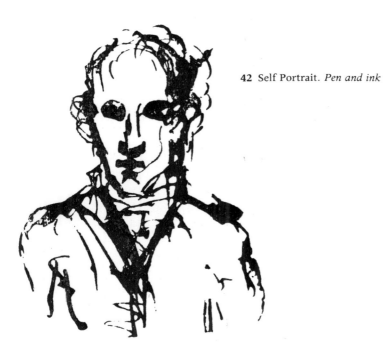

42 Self Portrait. *Pen and ink*

43 The Three Graces.

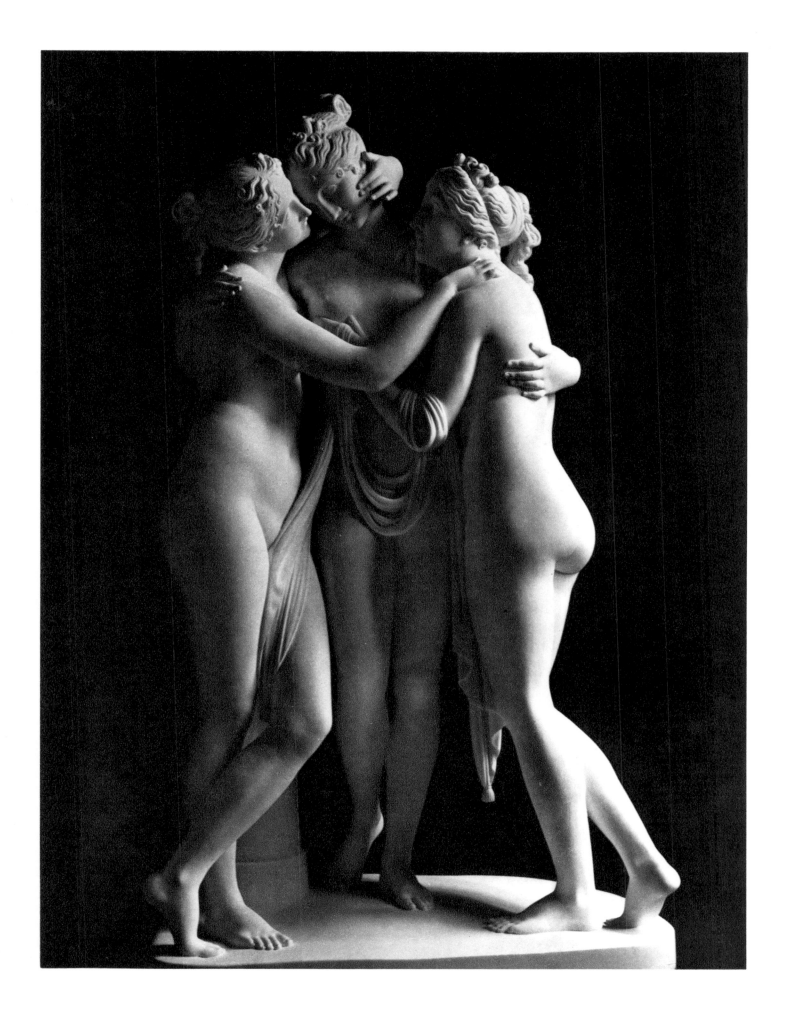

AUGUSTE RODIN

'THERE IS no recipe for improving nature. The only thing is to see. Oh, doubtless a mediocre man copying nature will never produce a work of art, because he really looks without seeing, and although he may have noted each detail minutely, the result will be flat and without character. But the profession of the artist is not meant for the mediocre, and to them the best counsels will never succeed in giving talent. The artist, on the contrary, sees; that is to say, his eye, grafted on to his heart, reads deeply into the bosom of nature. That is why the artist has only to trust his eyes. . . .'[1]

Rodin's comments on the *creative* acceptance of nature and the function of active, instinctual seeing as opposed to mere passive looking is an invaluable key to the nature and objectives of his art. For Rodin is, *par excellence*, the artist of action. His whole work—drawings, modelling and carving—exist and have their being in a state of continuous activity. There is in no sense a detachment from life, or even an arbitrary re-creation of form such as we find in the art of Maillol or Moore. His work is fundamentally a continuation of the life force itself; a carrying through of the *élan vital* into the realm of aesthetic experience and expression. In the ever flowing, pulsing rhythms of Rodin's work, art becomes life. The lesser artist converts life into art. Rodin uses neither metaphor nor symbol to paraphrase (and so complicate) the immediate impact of life and its forms. In his philosophy of the function of 'seeing' as the *a priori* condition of his art is contained the whole concept of his objectives as a sculptor and a draughtsman. To see, and simultaneously, to feel—to know and to experience—is the essence of all that he strove to accomplish.

In the simplest terms his sculpture is merely an extension of this kind of seeing. Compare *The Metamorphoses of Ovid* (**48**), the work which I have chosen as a typical sculptural achievement, with any of the drawings reproduced, and the comparison is instantly revealing. Drawing was the mountain-spring from which flowed the most characteristic of Rodin's sculptural projects. In the whirlwind of a line or the slash of an area of tremblingly delicate wash he created statements of breathtaking completeness. His use of clay was comparably swift, and total. He felt and he saw, and the experience was a unity. His line expounds not only the subtleties of anatomical tension and relaxation—the swelling and relaxing of muscular contrasts— but also the awareness and description of the totality of volume. 'Never consider a surface except as the end of a volume, and the more or less broad point which it directs towards you' he was told on one occasion early in his career by another sculptor who shared the studio where he was then working. He stuck to this advice. Any of the works which I have used here by way of illustration demonstrate the practice of this principle. Rodin's concept of drawing is inseparable from his objectives as a sculptor and both are inseparable from life. His knowledge of the human body was profound, but this knowledge would be arid and meaningless if it

were not always—in his case—closely related to an intensity of feeling which is no less magnificent, and no less powerfully communicated. Of the *Venus de Medici* he remarked: 'Is it not marvellous? . . . Just look at the numberless undulations of the hollow which unites the body and the thigh . . . Notice all the voluptuous curvings of the hip . . . and now, here, the adorable dimples along the loins . . . It is truly flesh . . . You would think it moulded by caresses.'[2]

And indeed, for Rodin, the act of drawing, the activity of modelling, were acts of love. Even the harsh, brittle line of the pen in his hands became a caress; warm and voluptuous like the gently exploring fingers of a lover as they move over the body of the beloved. In this respect it is apparent that the vitality of his drawings is the most natural and logical preparation for the actions and energies of his sculpture. *The Metamorphoses of Ovid* is a case in point; a natural metamorphosis of *esprit* into substance. M. Paul Gsell, a friend and confidant of the sculptor, has described Rodin's system of working. 'He had in his studio a number of nude models, men and women, in movement or reposing. Rodin paid them to supply him constantly with the picture of nudity in various attitudes and with all the liberty of ordinary life. He was constantly looking at them, and thus was always familiar with the spectacle of muscles in movement. Thus the nude, which today people rarely see, and which sculptors only see during the short period of the pose, was for Rodin an ordinary spectacle. Thus he acquired that knowledge of the human body unclothed which was common to the Greeks through constant exercise in sports and games, and learned to read the expression of feeling in all parts of the body. The face is usually regarded as the only mirror of the soul, and mobility of features is supposed to be the only exteriorization of spiritual life. But in reality there is not a muscle of the body which does not reveal thoughts and feelings.'[3]

Certainly one has only to look at a drawing by Rodin to *feel* the extent to which, in his art, the very soul enters into the configurations of anatomy. Whether his touch was conveyed through the glance of a pen, or more openly expressed through the pressure of his fingers and hands upon the clay, he extracted from his knowledge of the body the last ounce of inwardness; spiritual presence ripples through every contour. Each form is an extension of personality, and every relationship of forms and contours a marvellous revelation of the human spirit. Perhaps Rodin's greatest contribution to the history of European sculpture was his exuberant and fundamentally audacious conversion of the static forms of classicism into the ebb and flow of living matter. In terms of the representation of the human body Rodin's knowledge was as profound as that of the Greeks. His achievement was to set in motion the frozen forms of the classic eye. It was an achievement that eluded even the masters of the Renaissance, with their blinding passion for story, and their inability to see and *feel* the body as a solitary figure, alone and marvellous in its own right.

AUGUSTE RODIN
(1840–1917)

[1] *Artists on Art*. Kegan Paul: 1947. Page 325
[2] *Artists on Art*: Page 325
[3] *Rodin*. Phaidon Press. Introduction

55

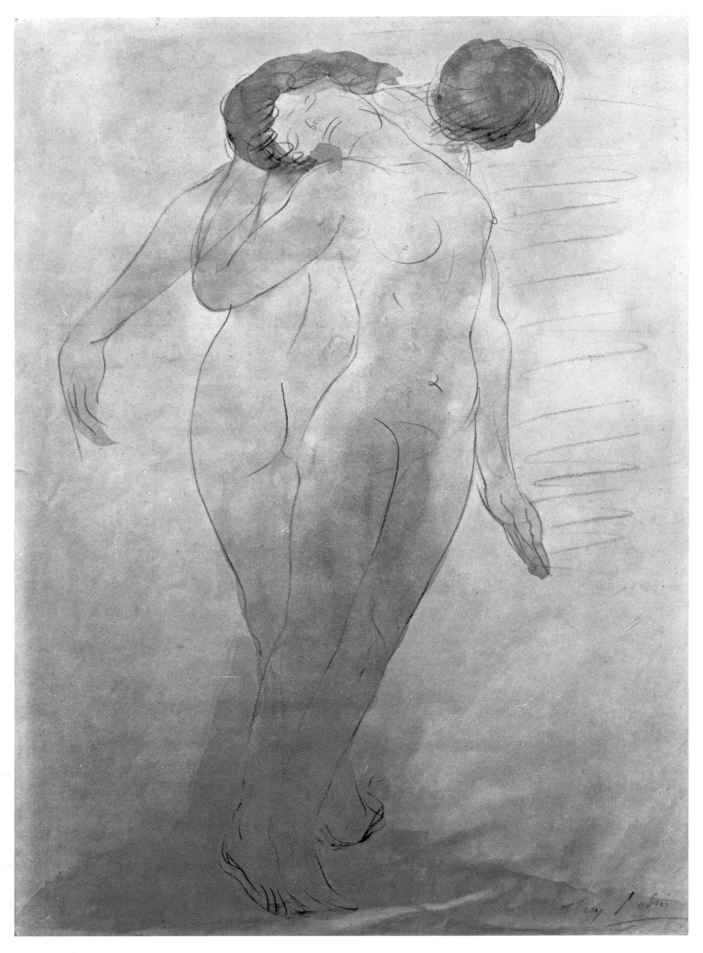

44 Two nudes.
Watercolour

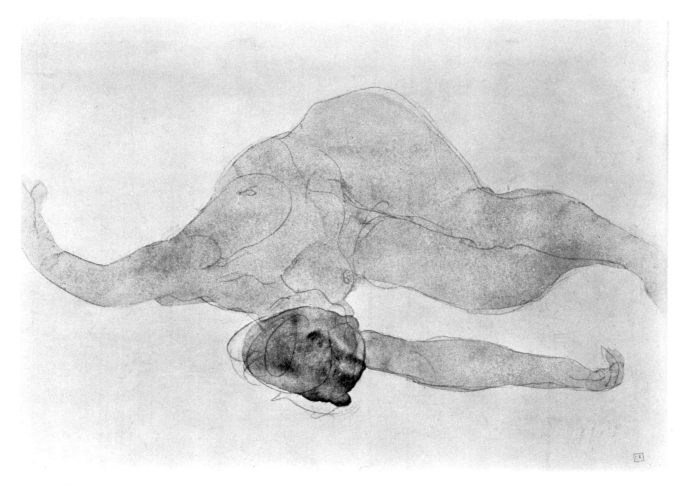

45 Nude lying down. *Pencil and watercolour*

46 Nude. *Pencil and watercolour*

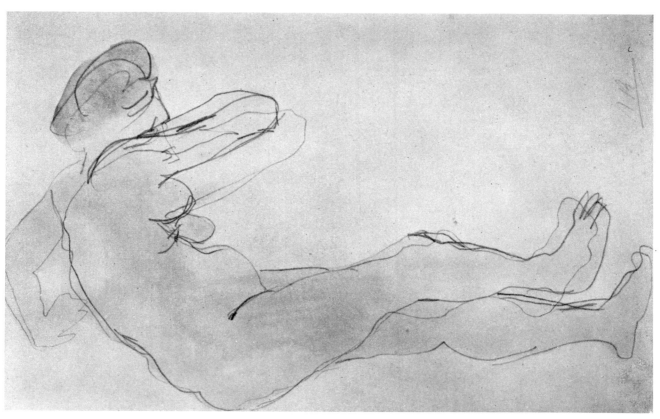

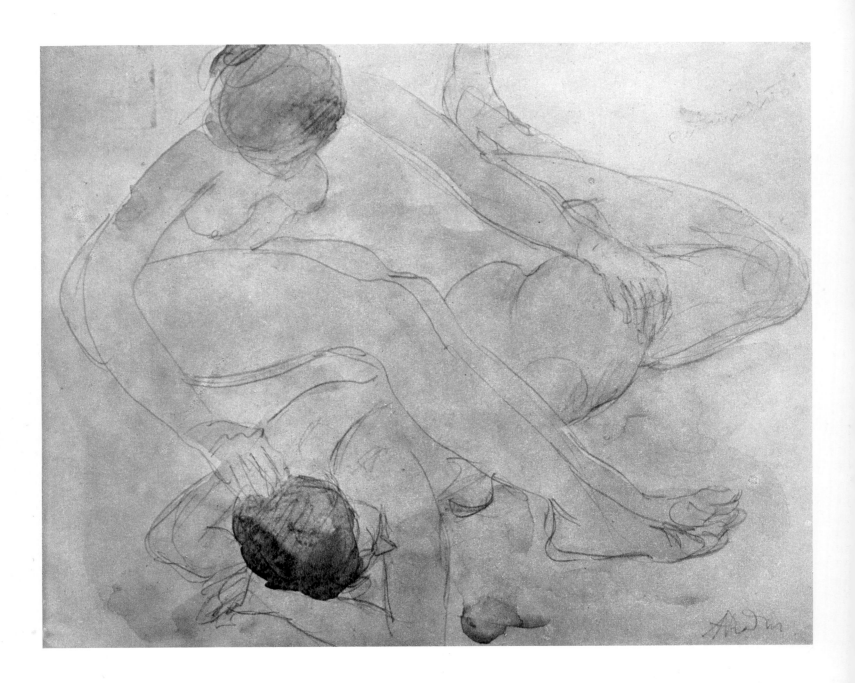

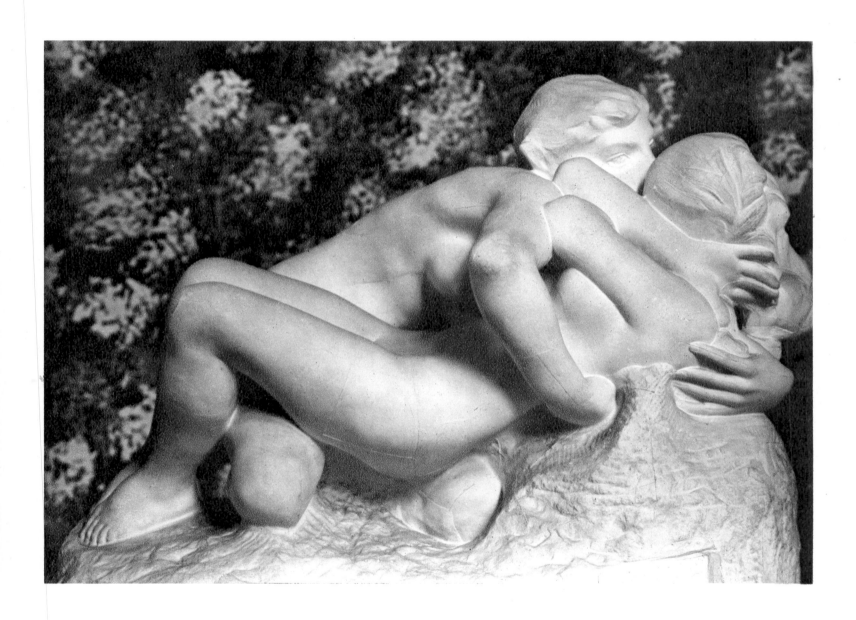

49 Two young nude girls. *Pencil and watercolour*

50 Seated nude. *Pencil*

51 Three nudes. *Pencil and watercolour*

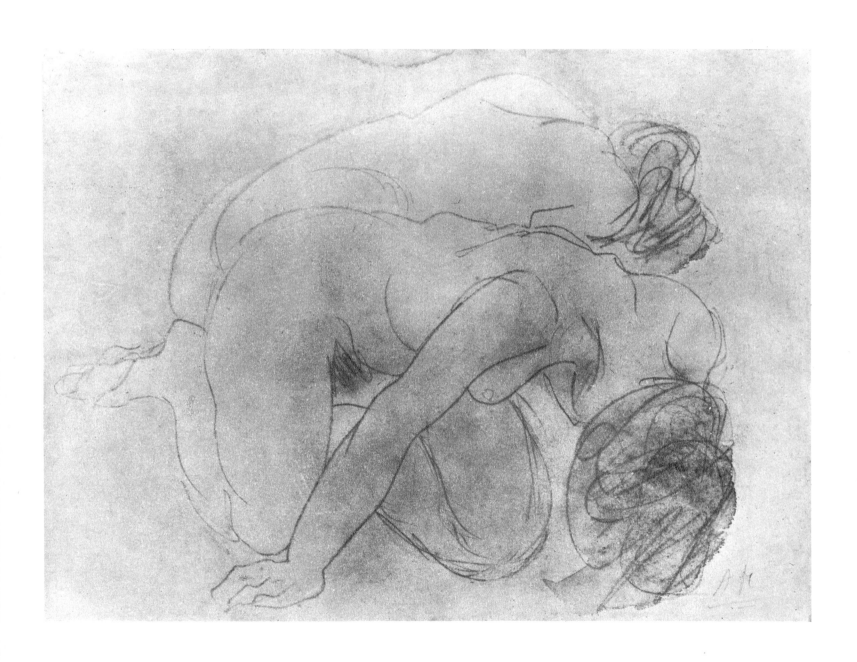

52 Two nudes crouching. *Pencil and watercolour*

ARISTIDE MAILLOL

(1861 - 1944)

THE ART of Aristide Maillol is essentially a striving to marry an aesthetic simplicity of form with a lyric dream. In this sense he stands in direct contrast to the tumultuous vitality and complexity of form which distinguishes the work of Rodin, his immediate predecessor. Whereas the latter was the master of action, Maillol brought to the sculpture of his day a quality of pervading stillness and silence. His art does not talk, it thinks. Or more precisely, it dreams. Critics and writers on art frequently refer to his 'classicism', and while certainly his affection for Greek sculpture is always apparent, his work is endowed with a poetic flavour which wholly belies the matter-of-factness of the classical vision. If the forms of his art are classical in their harmony and repose, the mood and feeling is anti-classical. The realism and practicality of Greek art is in no way comparable with the vein of pure lyricism which runs through Maillol's work. His vision is the very opposite of classical practicality, for he is primarily a poet unconcerned with everyday affairs. Even the large, simple, solid, often clumsy forms of his art in no way diminish the extreme delicacy of his lyric vision. His large bronze *The Mediterranean* (**plate** I) exemplifies all the points I have already made. It is also a crucial example of the sculptural culmination of his style of drawing, and his objectives as a draughtsman. Maillol never drew 'in line', but always in form. And since he was a poet, his drawings are a poet's working notes; the drafts and exercises, gropings and moments of committed inspiration that would later be worked into the completed forms of his poetic vision. Compare simply the drawing *Nude* (**53**) with *The Mediterranean*. As so often in his freely drawn, yet always compactly conceived studies of the nude, Maillol is here seeking the point of maximum stillness; the focal point of reverie and dream. The long, loose, flowing hair is used to heighten the sense of the lyric mood. The act of gentle combing, or arranging of the hair is one supremely conducive to reflection. In his sculpture, the convention of long, flowing hair—a common feature in his drawings—is usually restricted, the hair frequently being wound up into knots, or buns. But one feels that this lyric freedom was essential in the preparatory notes and studies that condition, perhaps more by their *esprit* and mood, the final aspect of his sculpture. It is the reflective *mood* of *Nude* which compares so strikingly with the spirit of *The Mediterranean*. It matters little how these two works compare in time— when they were done—since Maillol's art presents a fairly constant and unchanging pattern during the half-century of his working life as a sculptor. And this consideration apart, one of the most characteristic and satisfying qualities of his art is its timelessness. He is an artist of the sempiternal, not the temporal. His drawings— even those relatively fluid studies such as the *Reclining nude with black stockings* (**55**) —are suspensions of time, and in this respect also he exercises a fundamental prerogative of the poetic technique; the desire to pause for a moment, to hold and

consider, out of time, a fragment of truth. His drawings are the focal point of the containment of that shining moment. From these preliminary exercises in the lyrical suspension of time the artist moves naturally, easily and logically to the full flowering of his sculpture. Once again I would refer the reader to *The Mediterranean*.

If there was ever any conflict of attitude in Maillol's search for a 'classic' harmony and order it was finally resolved in his drawings. In the 'nineties, before the artist had shifted his interests to sculpture, he made decorative designs in the *art nouveau* manner. Echoings of this early affinity can be traced in his drawings particularly in the swirl and flow of the long tresses of hair. But this sweet convention is gradually shed, the hair knotted and bunned, and the last vestige of identification with the extraneous convention of a stylistic form disappears altogether, leaving only the unique shape of a 'classic' order which is common to no one but the artist himself. As Waldemar George notes in his study of Maillol[1] : 'If he is a classicist, then he is the creator of his own classic order!' Perhaps the one quality and characteristic of the *art nouveau* style which Maillol carried through, via his drawings, into the pattern of his sculpture was the long, decorative line. This stems not only from his initial association with *art nouveau*, but also from his admiration of the decorative qualities of Paul Gaugin, a painter who had a profound influence upon the conceptual evolution of Maillol's art, providing him as he did with the glimpse of a new art —simple, strong, and decorative. We can in fact look upon Maillol's work purely from the decorative point of view if we wish, for herein lies much of its strength, and the secret of its powerful, yet always unobtrusive harmonies. His decorative potential was, of course, most fully and clearly realized in his wood engravings, which may be considered as 'drawings' since their essence is essentially linear, and since it is impossible to consider the construction of Maillol's objectives and achievements as a sculptor without taking into account this vital aspect of his *oeuvre*. In his wood engravings (56) one finds the soul of the decorative line which is the skeleton of his art. It is this sinuous, decoratively configured line—reminding us again of Maillol's *art nouveau* origins—which threads its way through every aspect of his work. It is the line of pure adornment by which Maillol expresses in his drawing and sculptures the fundamental quality of the *Jugendstil* aesthetic, and by which this element in his work can be compared with that of Gustav Klimt.

So intimately are the drawings, wood engravings, and the sculpture of Maillol inter-related, that any attempt to separate and consider them apart is unthinkable. And this I take to be the crucial quality of sculptor's drawings as distinct from those of painters. They are not isolated sparkings, not fragments of personality thrown off in the heat of the moment. They are the breathing exercises of sculpture; the first, tentative searchings for the truth, the whole truth, which for the sculptor is only to be found in the limitless configurations of the round.

ARISTIDE MAILLOL
(1861–1944)

[1] *Aristide Maillol*. Editions Ides et Calendes 1965. Page 24.

65

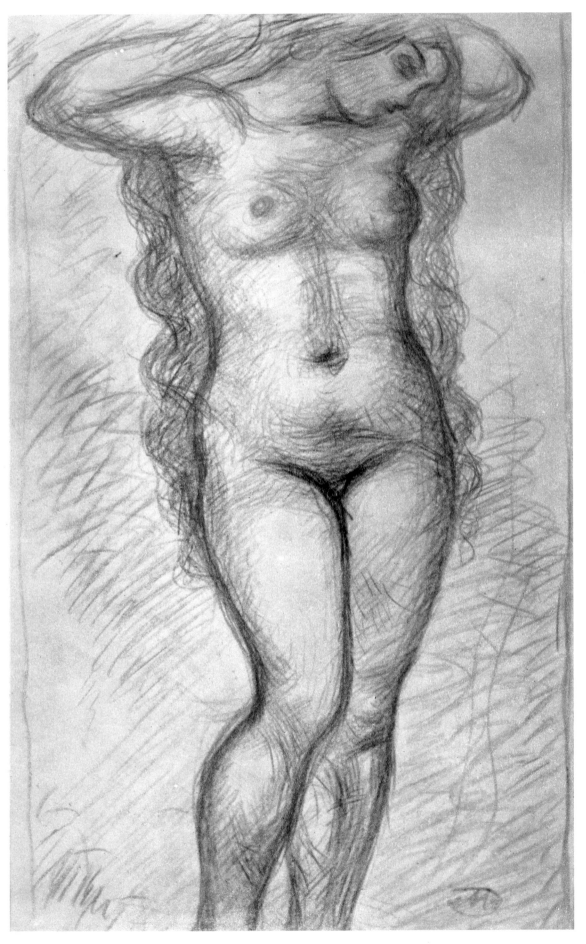

53 Nude. *Black crayon*

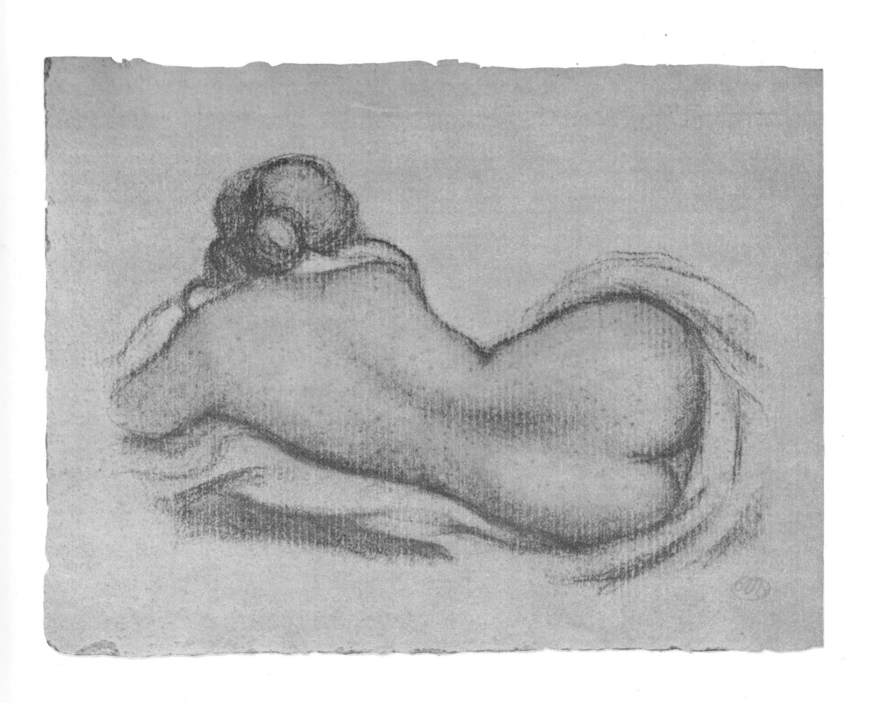

54 Reclining nude. *Red chalk*

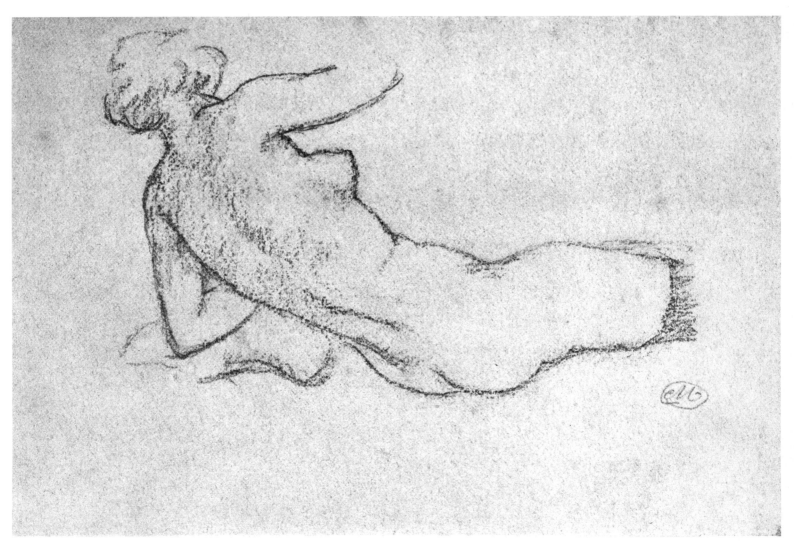

55 Reclining nude with black stockings. *Crayon*

56 Wood-engraving for Ovid's 'The Art of Love'

57 Thérèse. *Charcoal*

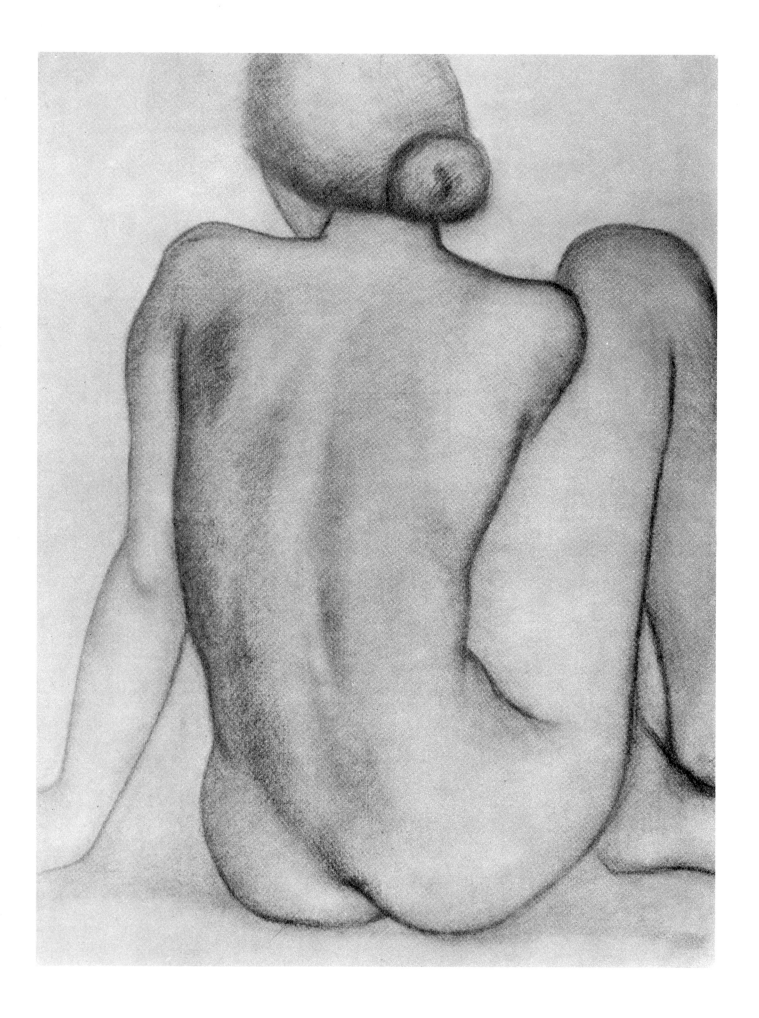

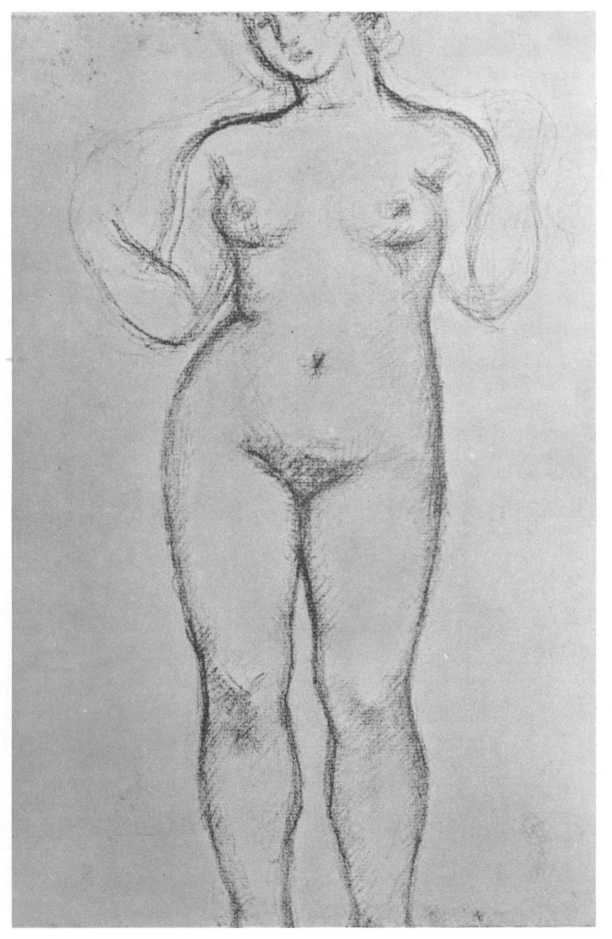

58 Venus. *Red chalk*

59 Woman lifting her skirt. *Pencil*

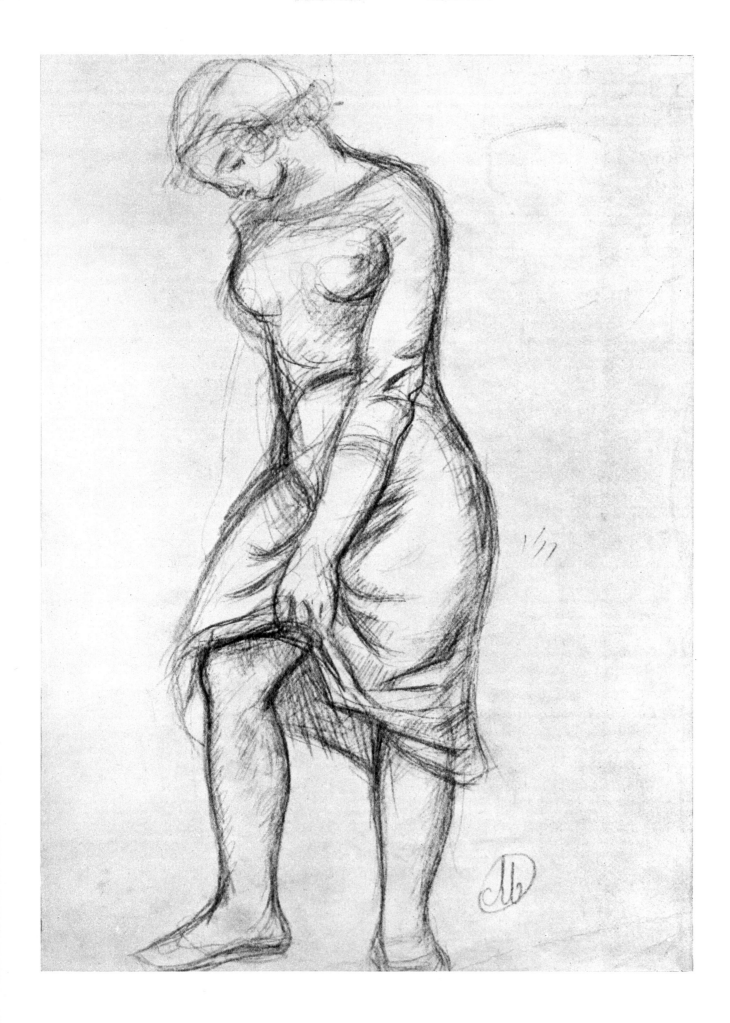

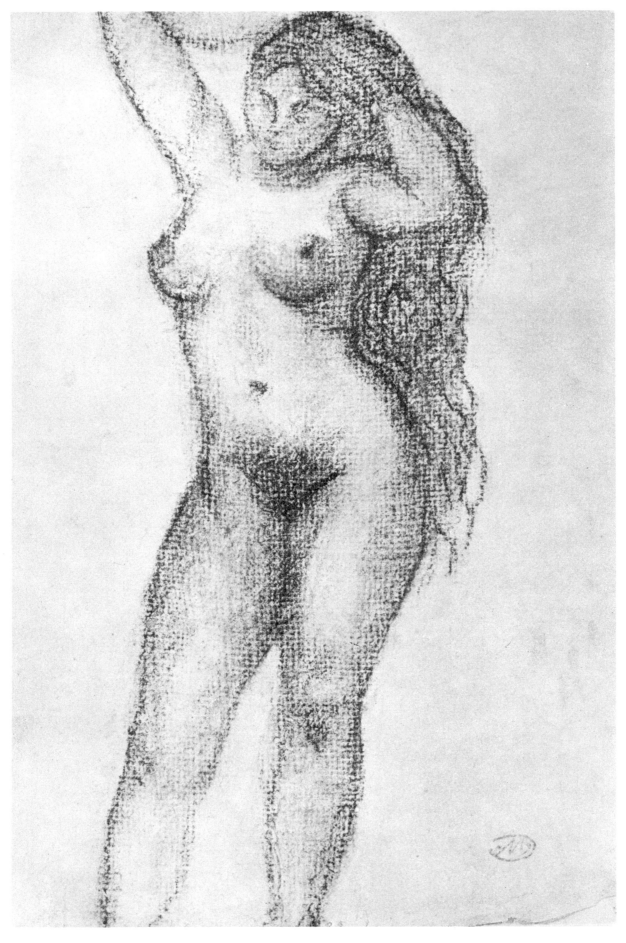

60 Dina arranging her hair
Red chalk

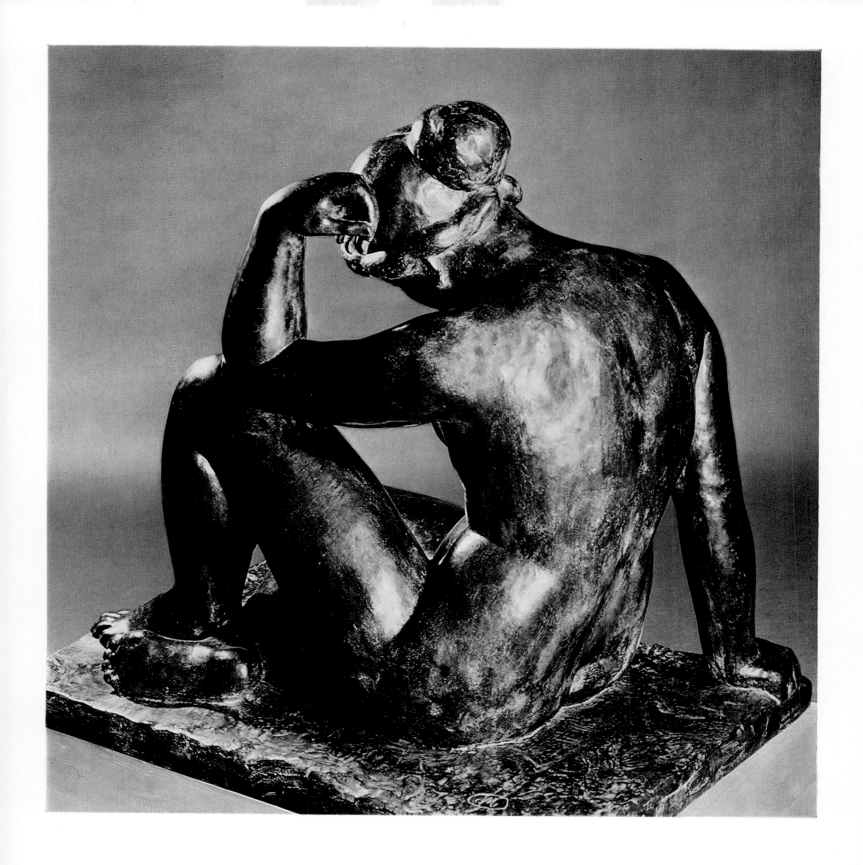

Plate I MAILLOL: The Mediterranean, 1902–5. *Bronze*

DAVID SMITH

(1906 - 65)

IF ONE were to describe the pedigree of artists like those of racehorses we could say of David Smith: Sculptor in steel, by White Heat out of Gonzalez and the American Industrial background. It is a fair summary of the artist's apotheosis and a good starting point for any study of his art. At the age of nineteen he began work at the Studebaker automobile factory at South Bend, Indiana, and to this apprenticeship belongs the evolution of his passion for steel as the ultimate material for his art, and the development of the technical skills for its manipulation and construction. The artist's destiny as a sculptor was to lie in the direction of an aggressiveness altogether consistent with the inherent brutality of his media, and expressive of the thrusting, pugnacious energies which were to drive modern American art into its most fruitful and dynamic decade, the 'fifties.

'Possibly steel is so beautiful because of all the movement associated with it, its strength and function' said Smith: 'Yet it is also brutal, the rapist, the murderer and the death-dealing giants are also its offspring.' And indeed the complementary elements of strength and brutality are the qualities which finally distinguish Smith's art. They are qualities apparent in all the drawings I have reproduced, any of which one can easily relate to the forms of his sculpture. The nude (61), no less than the other drawings, is a figure of strength and brutalism. But that Smith is able to impart a more civilizing dimension to these rudimentary qualities I shall show later. Yet, in the matter of appearances, the artist is not the master of grace and elegance; he extracts no lyric properties from the age of technology, as does Gabo. His art is based upon a heroic view of the sheer, awful power of the age of steel.

Starting as a painter, he began forging his structures under the influence of Cubism, the Russian Constructivists and the Spanish sculptor, Gonzalez. His early pieces are reminiscent of the 'rough hewn' aspect of Picasso's cubist constructions as well as of Gonzalez. I reproduce two pieces of David Smith's sculpture because I feel that in his case it is necessary to show that from the outset his sculpture was based upon the two primary and sustaining qualities of his art when seen as a whole— strength and brutality. He took no time, so to speak, either in evolving this philosophy, or in translating the concept into his own peculiar aesthetic terms. The difference between the *Construction in Bent Planes* of 1936 (62), and the untitled structure in mild steel of 1964 (65) is solely one of aesthetics. The expressionism of the earlier work is converted into the rigorous precision of the later structure. Both are strong, both brutal, but it is in the artist's *Bent Planes* that we can best see the extent to which, ultimately, he was prepared to submit his humanity (recoverable in another form, as we shall see) to the demands of a material that is, by its very nature, empty of humanity. 'The rapist, the murderer, the death-dealing giants' of the iron apocalypse could hardly have found a more ferocious or implacable symbolism. It is

DAVID SMITH
(1906–65)

echoed in the extraordinary drawing in enamel spray (**70**), though elsewhere in the drawings I have reproduced the sculptor, while expressing his concept of the strong and the brutal keeps alive and flowing the emotive, expressionist, humanist qualities which have been beaten out of his later steel constructions. These drawings, then, are not simply a preparation for sculpture, but an *atmosphere* in which the oxygenation of the sculptor's vision is kept in trim. They are 'breathing exercises', very closely related to the artist's working method. Speaking of a series of sculptures, he said on one occasion: 'None of these are preconceived. None of them are drawn. I take iron and an acetylene torch which runs on a track and is motor driven and put a tip into the right cutting thickness, and I cut shapes out, and then I throw them on the floor and pile up a big blob of shapes. And then I stumble over them and sooner or later relationships take place, and then if they are not complete, I complete them.' The drawings are the free, spiritual complement of this working method and they are even less bound by preconceptions. Here are the cut-up bits and pieces, the anatomized dynamic, the piling up of rhythms, movements, forces that will animate, implicitly (but never explicitly) the iron giants. They are neither blue-prints nor preparatory studies for sculpture as such, but, as I say, rather a process of spiritual limbering up, a stumbling over, a continuation—as natural as breathing, and as effortless—of the expressionist, humanist surge which is the *soul* of the sculptor's 'conceptual realization' (Smith's own phrase). To this extent the age of iron, the apocalypse of steel, the Armageddon of metal which in itself, and to use Smith's own words, 'possesses little art history', is invested with a dignity and with a presence that transcends the rapists' and the murderers' brutal strength. Without the drawings which precede their coming into being the sculptor's colossi would lack the light, the brilliance of spirit which is contained in the magnificence of his juxtapositions, in the effortless balancing of forms (volumes, girders, cylinders and blocks of cold metal) climbing upwards into the air like teams of acrobats. They, and his drawings, are perhaps more than anything a statement of man's unconquerable individualism; born here of the terrors of our time, an acknowledgement not only of strength and brutality, but a commitment to the idea and the ideal of man's immortal and imperishable freedom. The spirit, as here, will surely survive even the iron hatreds of our perishing civilization. If these drawings and sculpture were the last testament of twentieth-century man to be recovered in a millenium or two from the rubble of destruction, they would convey in their way as profound a sense of power, and of spirit, as the statuary and the hieroglyphics of Egypt or the vanished civilization of the Aztec.

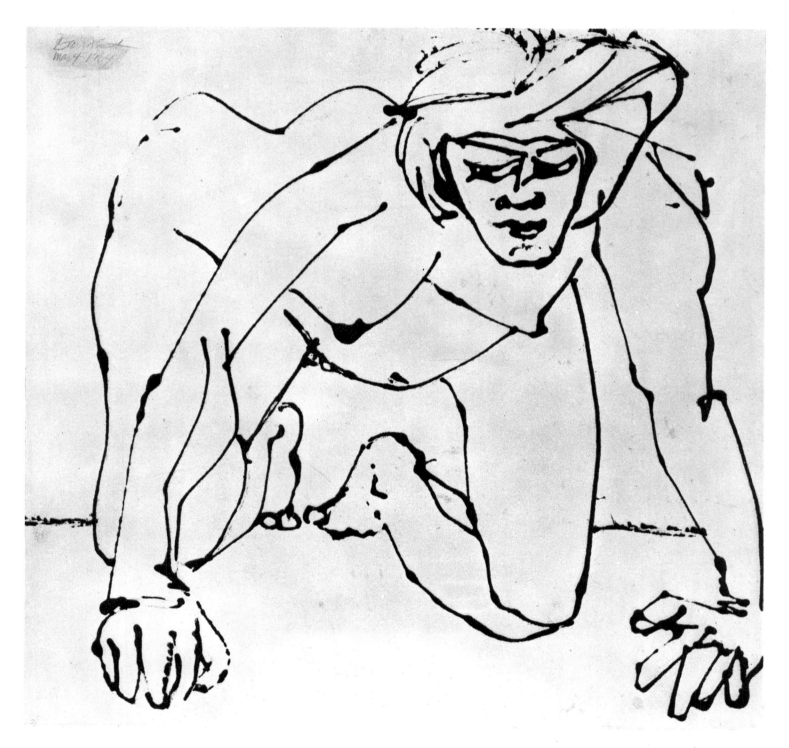

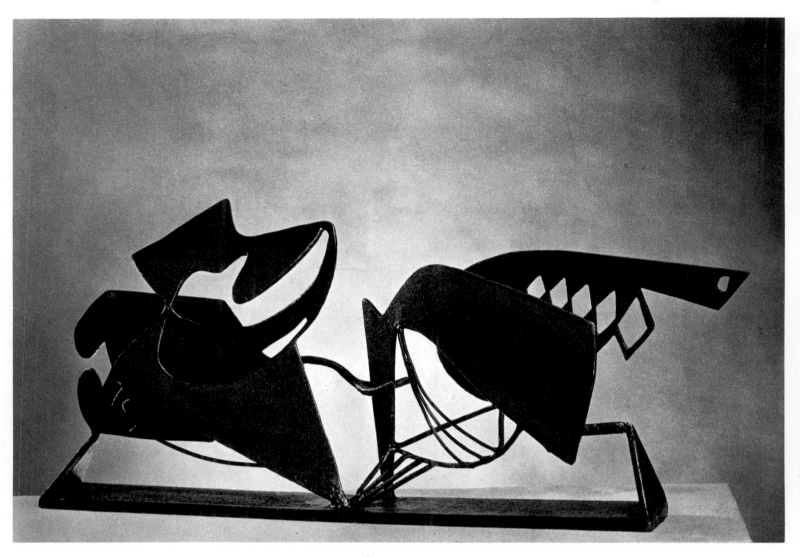

62 Construction in Bent Planes, 1936. *Iron, height* 13 *in.*

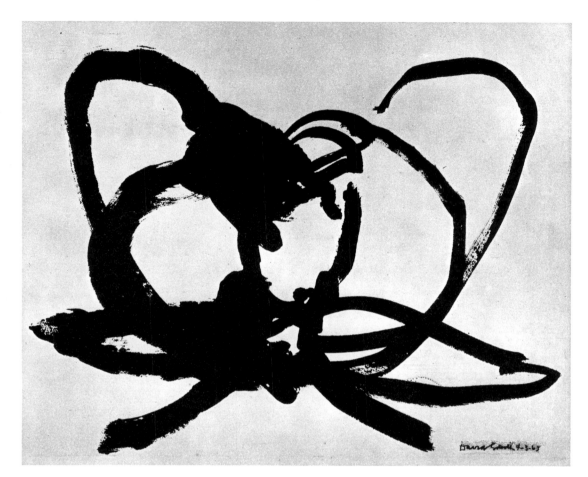

63 D.S. 4-3-63. *Ink and egg*

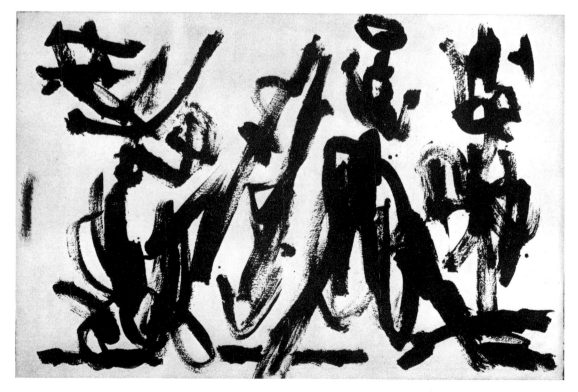

64 Dida 8-7-59. *Ink and egg*

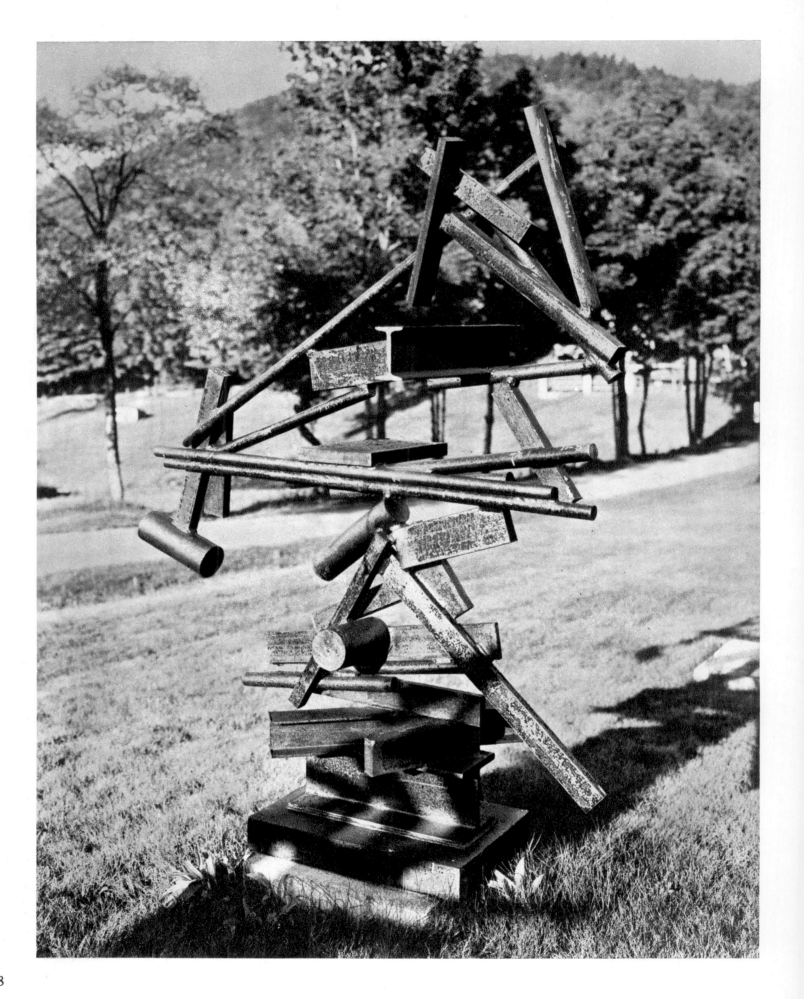

65 Untitled. *Mild steel, height 82¾ in.*

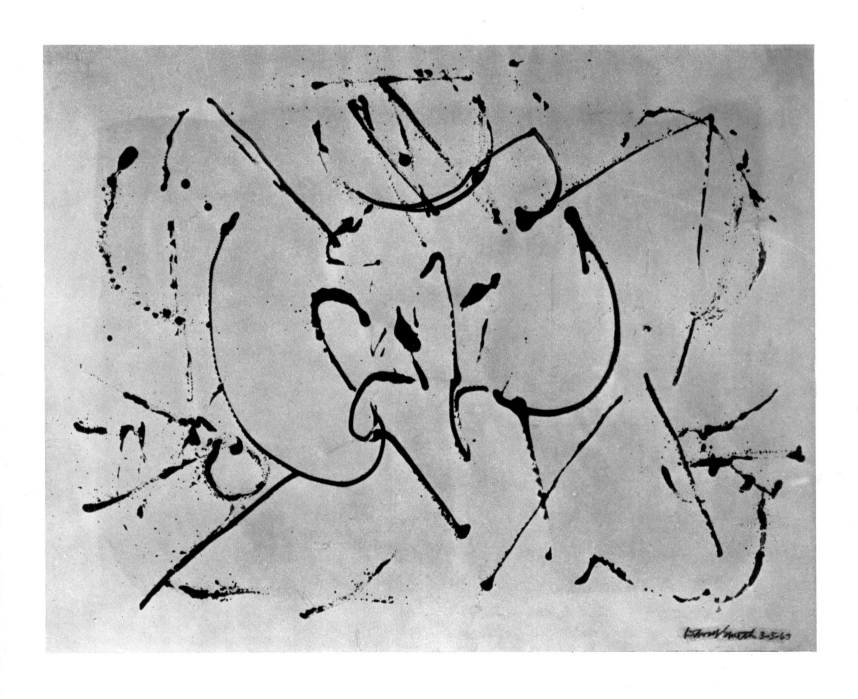

66 Drawing 3-5-63. *Enamel on paper*

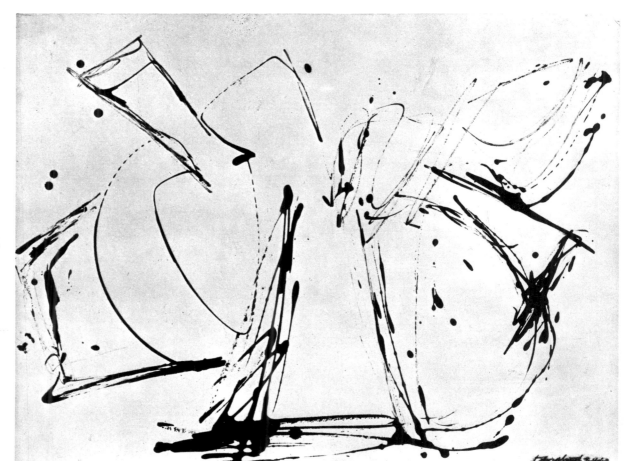

67 Drawing 3-4-63.
Enamel on paper

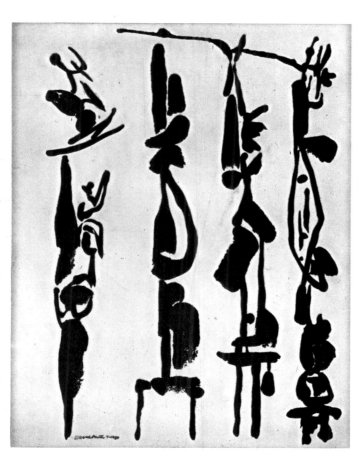

68 7/1954. *Ink and egg*

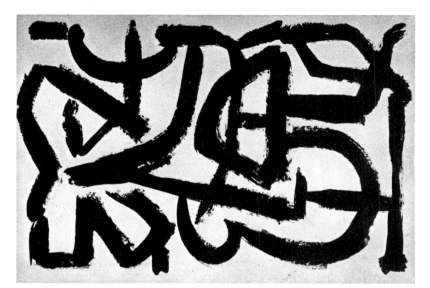

69 D.S. 1957. *Ink and egg*

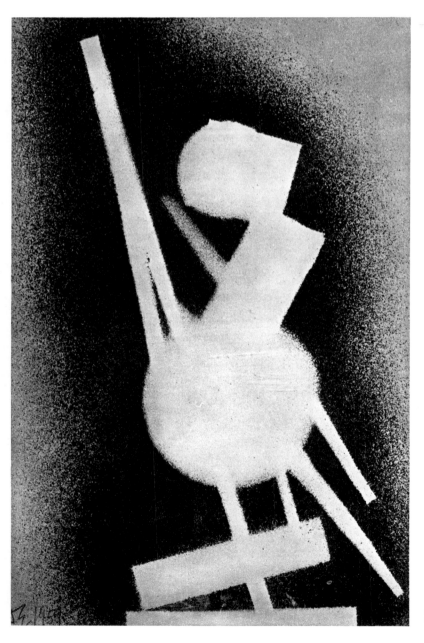

70 Drawing 1959–5. *Enamel spray on board*

81

JEAN HANS ARP

(1887 –)

I HAVE omitted any reference to the *organic concretions* of Jean Arp, the 'sculptures in the round' which belong to his middle period, because I do not consider these exercises in the 'natural process of condensation, hardening, coagulating, thickening, growing together . . . concretion is something that has grown . . .' (the statement is the artist's), to be the essence of his real contribution to the evolution of modern sculpture. Comparative human forms, comparative natural appearances, shapes, textures—as of wood or rock—are of the essence of sculptors like Moore and Laurens, but the essence of Arp is contained in those early associations with Dada which are not an organic extension of nature, but a form of intellectual-aesthetic protest against the mechanization made necessary by war. The wit, humour, satire and unabashed iconoclasm of Dada was a protest against the many depravities of a society—aesthetic as well as moral—that was to be extinguished in the holocaust. Arp was trained in this school, and has remained in essence a Dadaist. So, in his later sculptures, such as the piece in duralumin, *The Three Graces*, of 1961 (72), he returns to the original concept of Dadaist protest, only here his forms are in revolt, not against the mechanization of violence, but against the very concept of organic sculpture which places Moore, Laurens and others of their kind in the backward-looking rearguard of contemporary sculptors. When Paul Klee asserted that the true artist did not work from nature, but like her and in her, he could well have used the early and later works of Arp as an illustration of his argument. And if we take the term 'nature' in this instance to mean the whole, vast conspectus of daily life, then we can see how far removed is the art of Arp from the limited viewpoint of the organic sculptors. Unlike those sculptors who simply modify, extend, or otherwise produce variations on the theme of natural appearances, Arp creates fresh appearances, but these are as much distilled from the intellect and the imagination as from figures in nature. Using characteristic mid-twentieth-century materials such as duralumin, he makes a clean break with conventional organic substances such as clay.

In these later works, the Dadaists' original hatred of what is commonly regarded as 'art' is rekindled and the way cleared for the artist to introduce into his creations anything at all which his hand, eye, intuition or intellect feels compelled to use. In this process he is bound by no convention. He draws as he will upon the multifarious world of infinitely disparate things and substances. Even the commonest and least likely of everyday substances are grist to this mill, as in the beautiful string drawing, *Head, Bird and Navels* (71), which sets in motion an ecstatic sensation of light-headed floating. The gay movement of this delicious drawing can be compared with the exuberant rhythms of *Madame Torso with Wavy Hat* (73). Arp's drawings reveal a curious and fascinating relationship to his sculptures.

In these, and particularly in the reliefs, the shadows afford an ever-changing extension of the fixed, main shapes, adding a dimension of fluidity and surprise as the works are viewed in different settings and lightings. Drawings such as *Head* (**77**), *Writing* (**75**), *Wreath of Grass* (**78**), or *Shadows* (**74**) are like the ghostly shadows of some marvellous, unseen objects. One can even imagine their likely shape and form from these drawings.

Arp's consistency is remarkable. Apart from occasional sorties into the restricting dimension of traditional organic sculpture, he remains essentially the artist of protest, breaking at all points the cloying limits of 'official' art. His consistency is clear from a comparison between the two pieces of sculpture I have chosen by way of illustration (**72**, **73**). A gulf of some 45 years is here bridged with an effortless continuity of vision and intent. In the later work, relief forms are established in space; they are free-standing, but they are not organic. They owe nothing to the anthropomorphic tradition of nineteenth-century sculpture. These Graces have the immaculate, silent personality of things whose destiny is not consumed by emotion; by the agony of the human situation. They are forms like shafts of moonlight falling on still, clear water.

The drawings are a form of intimate personal counterpoint to the melodies of his sculpture. *Doll* (**76**) has the same cool, impersonal elegance as is possessed by the forms in *The Three Graces*. Considered in another light his drawings are maps plotting the subtlest mental cartography, or like snapshots from the dark side of some new cerebral planet hitherto uncharted, as in drawings like *Head* (**79**), the *Wreath of Grass* or *Shadows*. Here is the atlas of a fresh aesthetic geography, as though seen from the air, from space; it is a guide to what we shall see on the ground in his sculptures. Gertrude Stein once said that analytical Cubism provided the spectator with a sort of aeroplane's eye view of the world at a time when few men had seen it from this point of vantage. In the same sense, in the drawings of Arp the landscape is laid out beneath us, marked by strange and beautiful boundaries, as in the delineation and break-up of the areas in *Mondsand* (**80**). Flying in low we find this curious and compelling geography perfectly matched and complemented by *Madame Torso*, and at ground level by the *Graces*.

The simile may be fanciful, but it is I believe relevant and admissible. Arp is an artist of fancy who stimulates by his delicate and provocative caprices a mood of whimsical imagining in the mind of the spectator. It is only by the addition of one's own fancies that the works of this remarkable master can come fully into their own strange life.

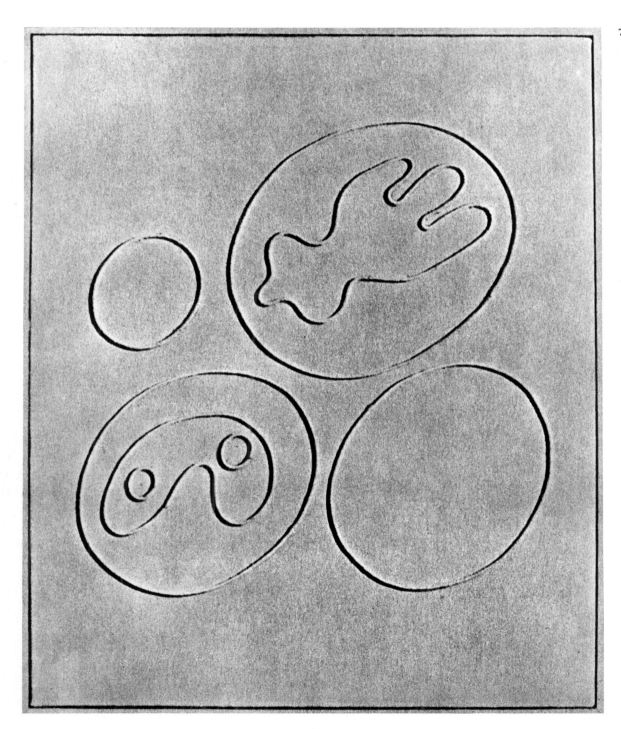

71 Head, Bird and Navels, 1929.
String on canvas

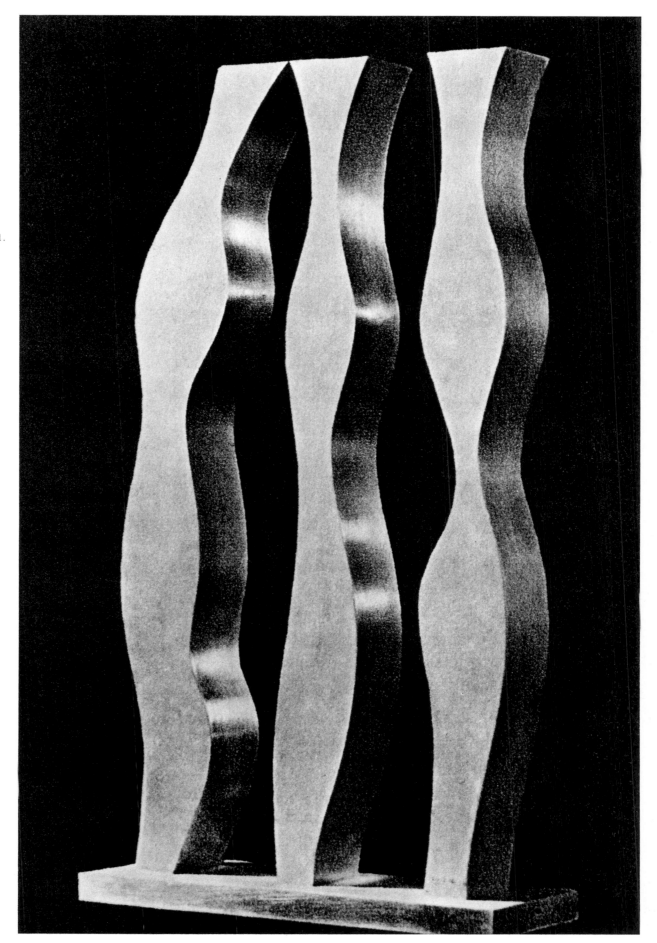

72 The Three Graces, 1961.
Duralumin

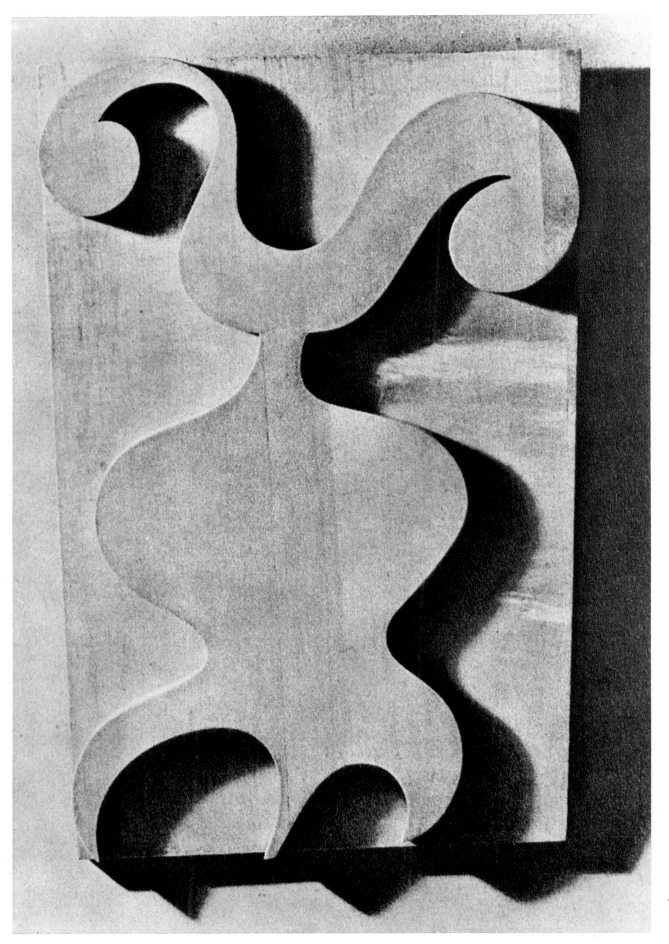

73 Madame Torso with
Wavy Hat, 1916.
Painted wood relief

74 Shadows, 1958. *Pencil*

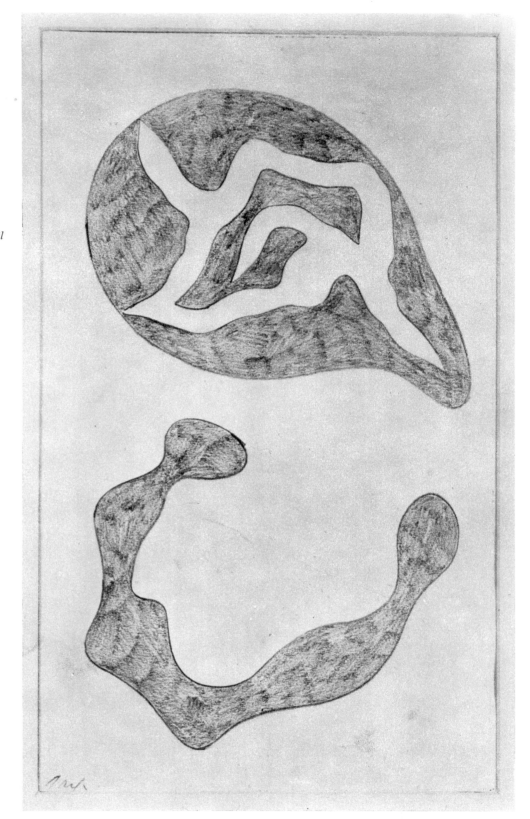

75 Writing, 1928. *Indian ink*

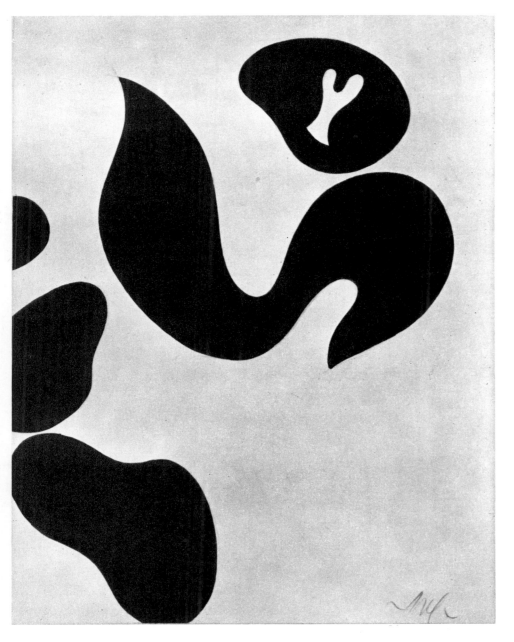

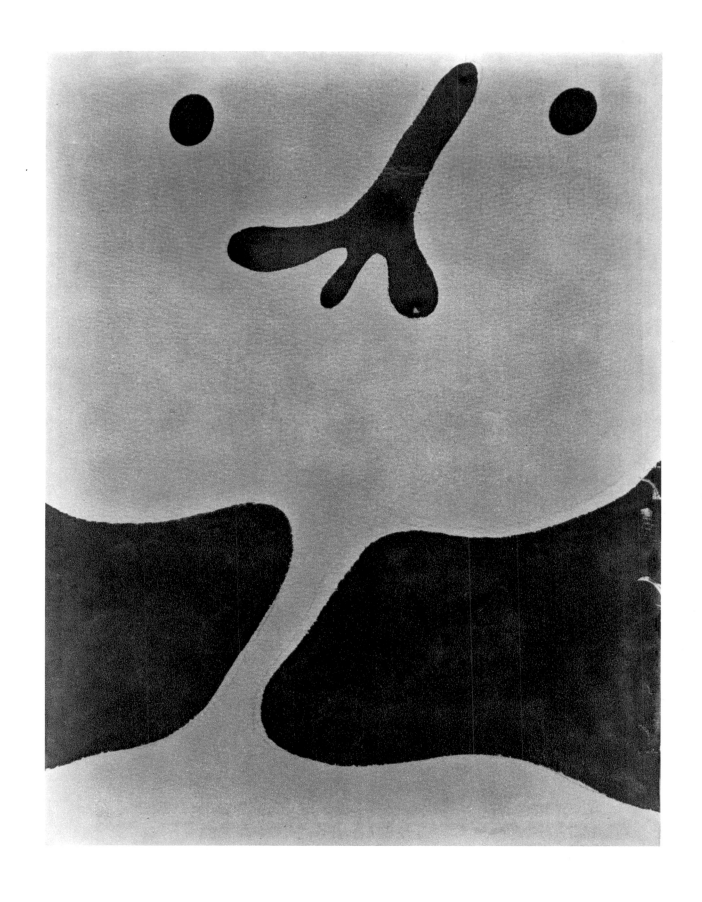

77 Head, 1924. *Watercolour*

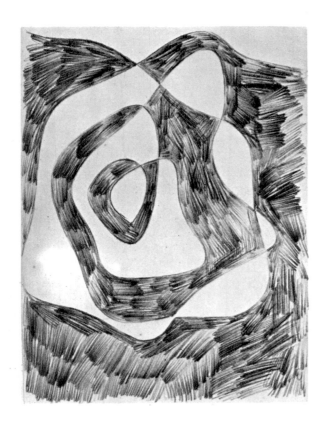

78 Wreath of Grass. *Pencil*

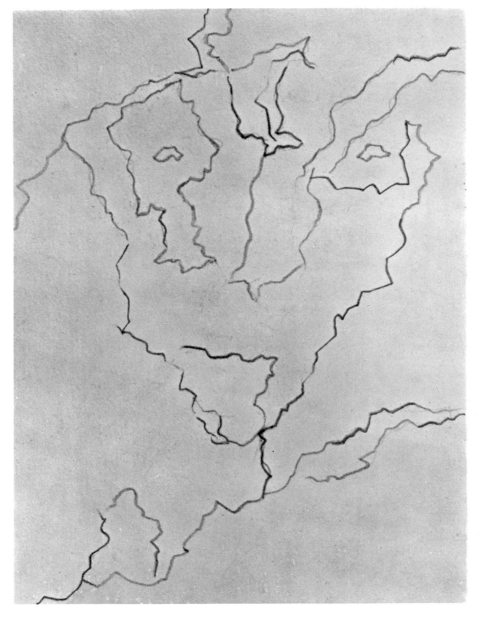

79 Head, 1954. *Pencil*

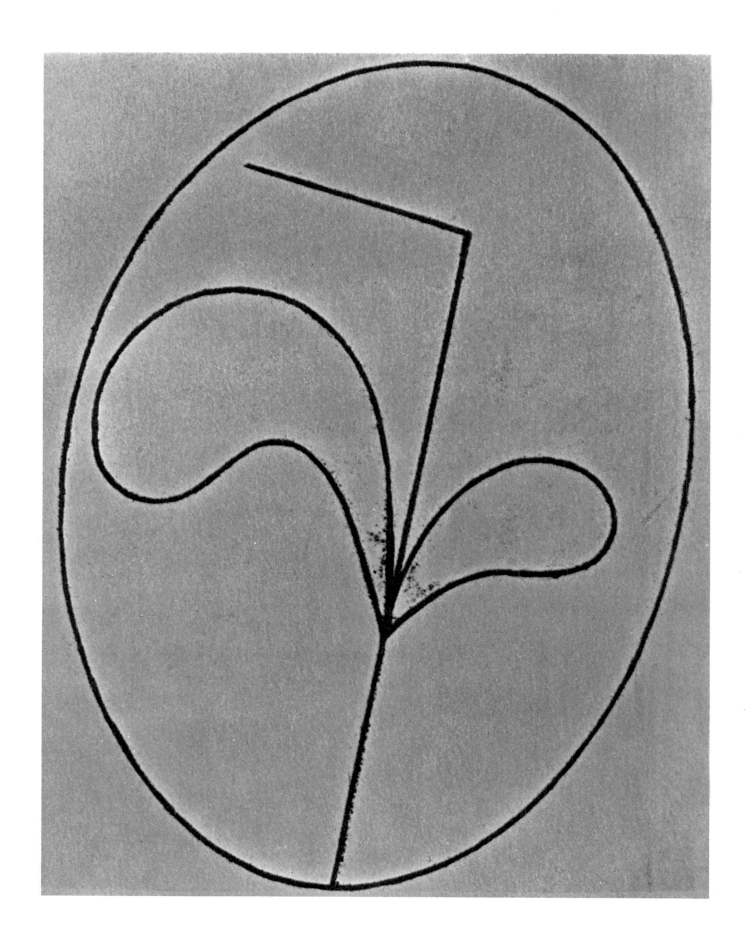

80 Illustration for the collection 'Mondsand', 1959.

ALBERTO GIACOMETTI

(1901 - 66)

AS THE demon of anti-sculpture I have included Giacometti in this volume because he illustrates so well the dilemma of an age which has neither the honesty nor the courage to admit that novelty is the weakest link in the chain of aesthetic events. Wyndham Lewis long ago referred to all this as stunt crusading. For the critic to talk today of standards and values is to risk the contempt of those fashionable writers who have already overloaded (and may shortly overturn) the babbling band-wagon of stunt supporters. Let me say at once that Giacometti is far too clearly an artist of integrity to merit any such labelling. Not so his 'supporters' however who, in devising complex and incomprehensible terms to describe his art, have themselves produced the stunt.

Today, the first concern of many art critics is to create the impression that they alone have deduced meanings and significances in a work of art which have hitherto eluded the other fellow. The stunts are common property; their interpretation is purely personal. But I think that the critic must write from the standpoint of an accepted convention; from the threshold of agreed standards and values. When writing about sculpture, for example, it is first necessary to define it. Quite clearly it has to do with volume, and with scale, since a stone carving six inches high has volume, and can, relatively, displace a sizeable area of space. Henri Gaudier-Brzeska said that 'Sculptural feeling is the appreciation of masses in relation' and 'Sculptural ability is the defining of these masses by planes'. I too am of this opinion. It is not sufficient, therefore, to stand a 'modelled drawing' in space as Giacometti has frequently done and call it 'sculpture.' Much of his later work is related to this convention, and it is about this least significant and least sculptural aspect of his work that most nonsense has been written. What David Sylvester has titled *The Residue of a vision*[1] is in fact no more than the residual waste-product of a vision that had been declining in intensity since the superbly sculptural achievements of Giacometti's early work. Sculpture cannot be seen, or assessed (not even in his case the much vaunted 'theme of spatial relationships') unless the shapes which displace space, and are themselves related to other shapes themselves displacing space (for instance the compositions of Moore and Hepworth) possess a volume proportionate to the volume of the immediate area of the shapes displaced. There is a law of proportionate balance here which loses its meaning if the volume of sculpture is too weak to support or offset the surrounding volume of space. This is what happens if you solidify arrangements of knitted lines and stand them in space—they are drowned (90). Thus Giacometti's modelled drawings, which are little more than arrangements of congealed lines, are rendered largely impotent by the sea of space which envelopes them. One cannot imagine Michelangelo conceiving the germ of *David* in the form of a modelled pen drawing. Other comparisons of this sort can be made by the reader out of his own knowledge.

Even prehistoric and primitive carvers intuitively understood this fundamental principle (the *Venus of Willendorf* is a perfect example).

In his portrait modelling of course, Giacometti has often returned to the concept of monumental sculpture but, as I have said, I am concerned here primarily with the fallacy of his 'modelled drawings', and the irrelevance of the build-up which this aspect of his work has been accorded by the critics. The significance of Giacometti's sculpture of this type is almost certainly philosophical and metaphysical rather than sculptural. To understand the nature of the philosophical-intellectual conflict which exists at the heart of the artist's *oeuvre* one must first realize that no such conflict exists in the work of sculptors such as Moore and Michelangelo, who are primarily concerned with the creation of physical monumentality. Conversely, Giacometti is obsessed with the need to whittle away volume; with a philosophical and intellectual inability in later years to stomach sheer mass.

During his early years Giacometti became depressed by his sense of the impossibility of representing what he actually saw, and so he started to work from memory rather than from the model. Unlike Moore, or Michelangelo, who have adapted the forms of nature to their own concept of the physically monumental, Giacometti has been mainly concerned with diminishing the idea of volume to coincide with his notions of a residual sensation of reality. This he envisaged as 'a sort of skeleton in space . . . never a compact mass, but like a transparent construction'. In many of his drawings he has striven to render apparent this pale, residual ghost of reality. To what end? The answer must perhaps be sought in the artist's association with the philosophy of Surrealism, a movement with which he was closely identified in the 'thirties. This involved the notion of an interior vision (dreamed or imagined) insubstantial in the physical sense and, by its very nature, the antithesis of the concept of monumental sculpture. In 1933 he wrote: 'For some years now I have only realized sculptures which have presented themselves to my mind in a finished state. I have restricted myself to reproducing them in space without changing anything and without asking myself what they might signify.' *Without asking myself what they might signify*; this is a metaphysical premise, and in sharp opposition to the sculptural philosophy of any other artist represented in this book. To the period in question belongs *The Palace at* 4 *a.m.*, the celebrated Surrealist sculpture for which I reproduce a preliminary drawing (**85**). Giacometti returned to working from the model for a five year stretch, 1935–1940. 'Nothing is like what I imagined it to be' he wrote subsequently, 'A head (I soon left the figure aside, it was too much) became an object completely unknown and without dimension.' In 1940, after he had ceased to work from the model, he began to make

ALBERTO GIACOMETTI
(1901–66)

ALBERTO GIACOMETTI
(1901–66)

sculptured heads and standing figures from memory. 'To my terror' he wrote, 'the sculptures became smaller and smaller . . . A big figure seemed to me to be false and a small one just as intolerable, and then they became so minuscule that often with a final stroke of the knife they disappeared into dust. But heads and figures only seemed at all true when minuscule.' Giacometti's perennial struggle has been the desire, intense and consuming, to diminish size and physical volume. His philosophy of the imagined as opposed to the real, his need to reduce the pressures and clamourings of physical reality in the search for the residual ghosts of an actual world which plays little part in his ultimate view of things until it has been so reduced, is most clearly expressed in his drawings. These frequently represent a passionate attempt to destroy the sheer, physical substantiality of the European sculptural tradition. His is the art of ghosts, a metaphysical longing to transform the oppressive reality of material existence into a light and wispy shadow. In this sense he remains a Surrealist.

In some of his later drawings such as the head of *Diego* (**86**) and the drawn oil (**83**), also a study of Diego, one is confronted with the paradox of a return to physical volume. But this I believe to be merely a form of conditioned aesthetic reflex; a nostalgic return to prototype imagery clearly cancelled in the ferocious scribbling which destroys the form of the pencil portrait, while accepting for a brief and hesitant moment a glimpse of the physical Diego in the oil drawing. The true and essential Giacometti is to be seen rather in such drawings as the *Standing Woman* of 1947 (**88**), the ghostly portrait of *Annette* (**87**), and the anti-sculptural, volume-smashing figure of the *Man Pointing* (**90**). All works in which physical presence is reduced to a minimum.

The drawings of the artist are a preparation for the diminishment of the physical substance of the European Sculptural tradition. In this sense Giacometti is the anti-hero of my study.

[1]Catalogue of the Arts Council exhibition: Tate Gallery, 1965

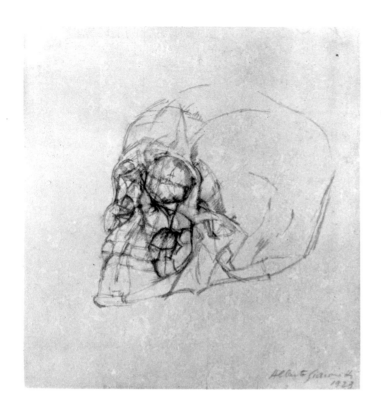

81 Drawing of a skull, 1923. *Pencil*

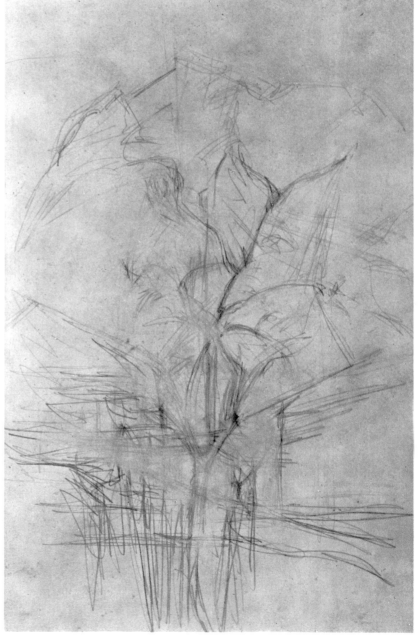

82 Landscape with tree, 1947. *Pencil*

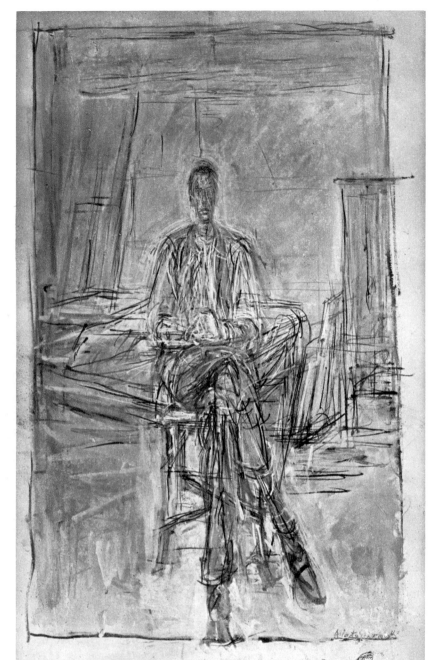

83 Seated man, 1949. *Oil*

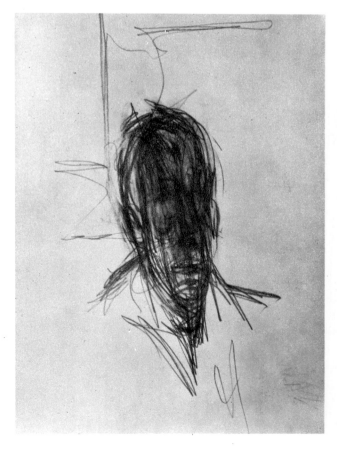

84 Head. *Pencil*

85 Drawing for 'The Palace at 4 am', 1932. *Pen and ink*

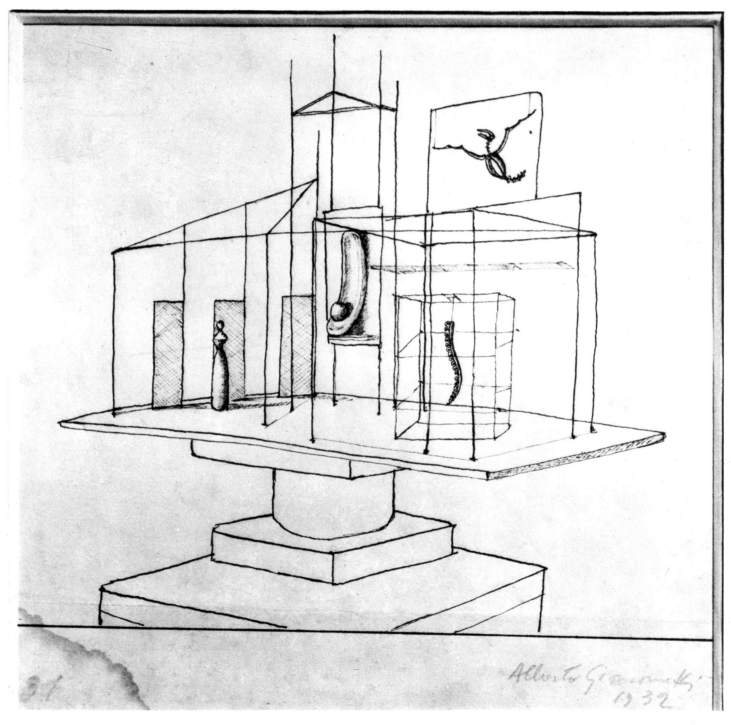

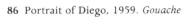
86 Portrait of Diego, 1959. *Gouache*

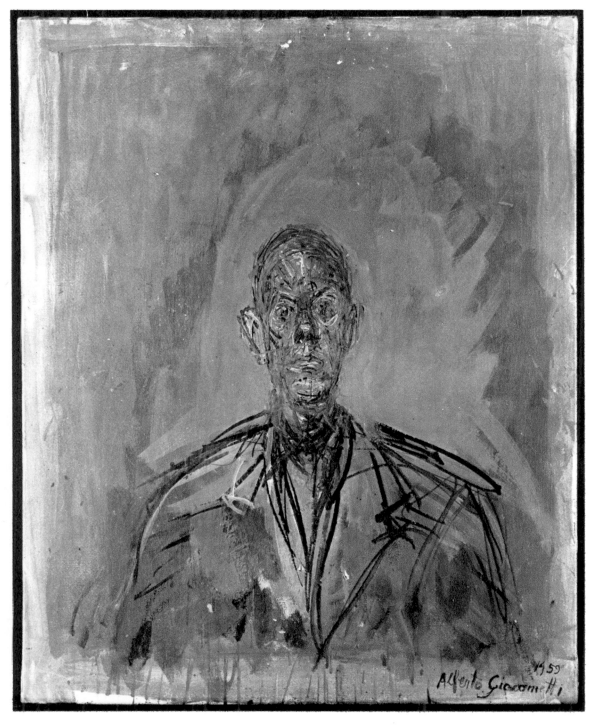

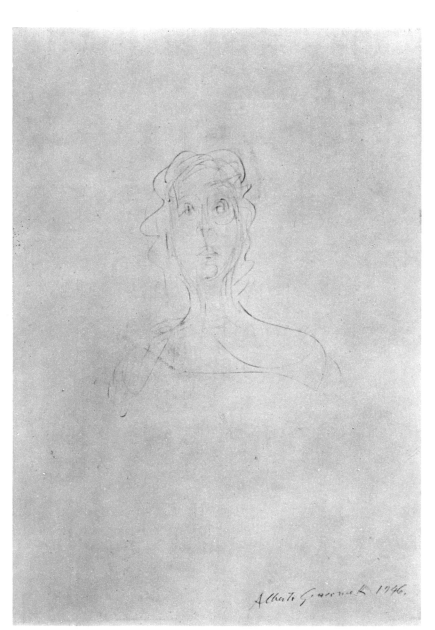

87 Portrait of Annette, 1946. *Pencil*

88 Standing woman, 1948. *Pencil*

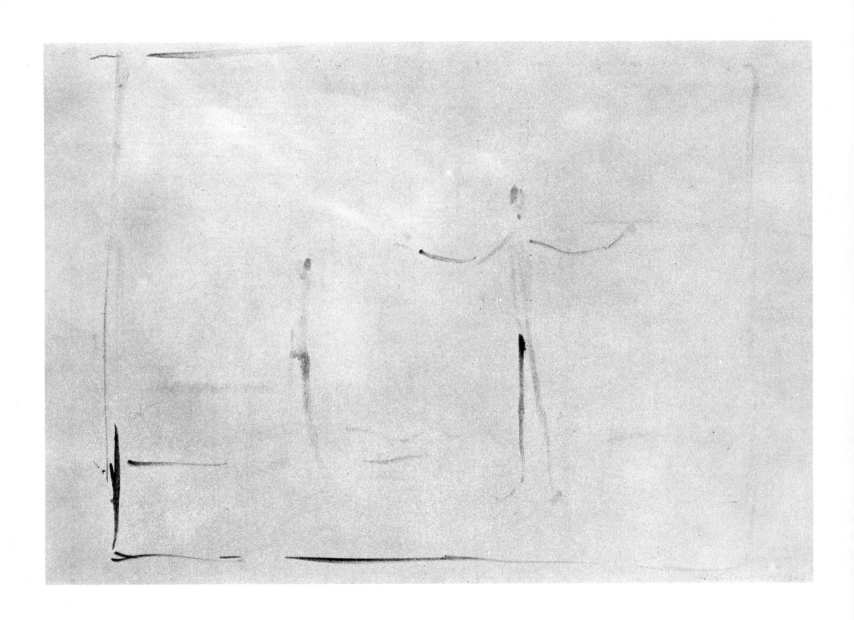

89 Figures, 1947. *Brush and wash*

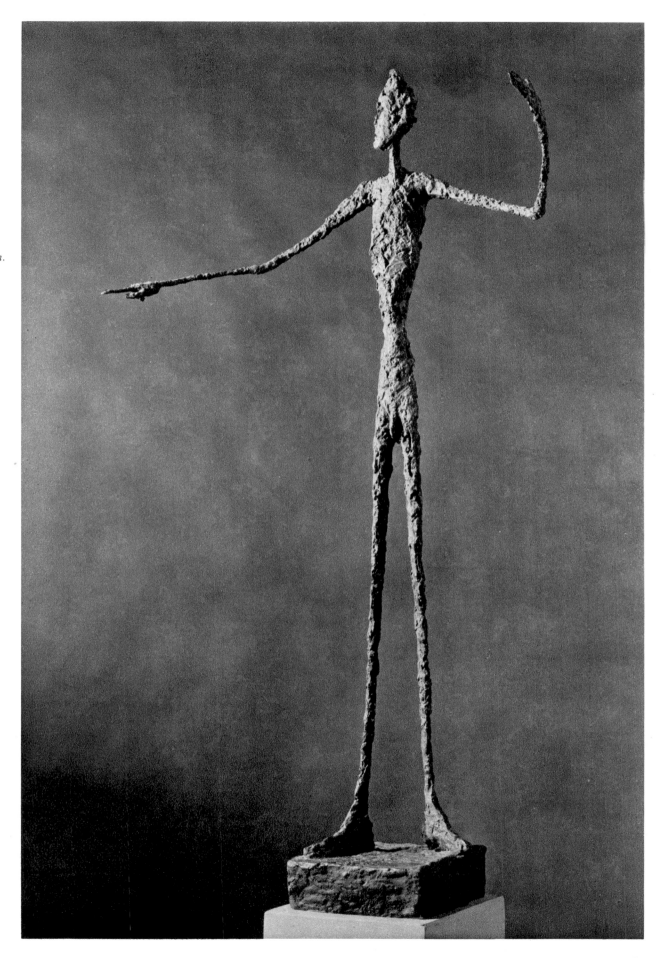

90 Man Pointing, 1947
Bronze, height 69½ *in.*

NAUM GABO

(1890 –)

THE LEITMOTIF of *art nouveau* was the whiplash line. It derived its curvilinear substance from the forms of nature. The *leitmotif* of the constructivist idiom is the line of the coiled spring; the line of machine forms. The organic forms and substances of nature are here replaced by the inorganic, but no less vital and energetic, forms and substances of industrial material: steel, glass, wire, metal sheeting, perspex, chromium tubing. The comparison is revealing. Art is a continuous process of action and reaction. *Art nouveau* was initially a potent reaction against the dead historicism of the first three-quarters of the nineteenth century: a reaction crystallized in the unashamed deployment of the swirling line; the line of nature. Constructivism, originating in Russia, was part of the reaction against the finally cloying, stifling dead-weight of figuration. *Art nouveau* also was partly a reaction against this factor. But whereas on the one hand the *line of nature* was the *zeitgeist*, on the other, the main impetus was to stem finally from the *line of the machine*.

Early in the present century, Gabo (and his brother Antoine Pevsner) created constructions of a purely non-figurative character. Gabo, who had been in Munich and Paris during the period 1910–14, was familiar with the objectives of analytical cubism, and its later extensions into the field of Synthetic Cubism. His *Constructed Head* of 1916 (**92**) displays a clear appreciation of the Cubist objective. Later, on his return to Russia in 1917 (he was born in Bryansk) and following a period in Oslo with his brother, Gabo joined Kandinsky, Malevich and Tatlin on the teaching staff of Vchutema, the Moscow School of Art. The time was ripe for the creation of yet a new *leitmotif* that would emerge, not from the ebb and flow of natural forms, but from the 'nature' of the industrial world. The informal line of nature was now superseded by the formal line of a technocracy from whose essence the Constructivists were to extract and evolve a new aesthetic. At first, in the patterns of *art nouveau*, form develops as it will; the artist renounces the right—or the need—to exert a strict control. As in nature the ramifications of form are wandering and arbitrary. By contrast, Gabo was well prepared to enter into the spirit of the new age, the era of controlled non-figuration which had already been heralded in the later stages of *art nouveau*; especially as exemplified by the designers of the Glasgow School, Arthur Macmurdo and Charles Rennie Mackintosh.

Naum Gabo had trained originally in medicine and the natural sciences. Later he studied civil engineering. His wide range of interests embraced mathematics and technology. The *leitmotif* of the controlled 'industrial line' is apparent in most of Gabo's drawings, even extending to the studies of 1926 (**91**, **96**), and the cubism of his drawing for a *Constructed Head* (**92**) which is so closely related to the *Constructed Head* of the same year. The sense of constructive industrial substances invades Gabo's anthropomorphic subjects. But he has never been content to describe his

Constructivist works as mere exercises in abstraction. He wrote on one occasion: '"Abstract" is not the core of the Constructive Idea I profess. The Idea means more to me. It involves the whole complex of human relation to life. It is a mode of thinking, acting, perceiving and living. . . . Any thing or action that enhances life, propels it and adds to it something in the direction of growth, expansion and development is Constructive.'[1] It is clear from this statement that while Gabo the sculptor works primarily with the constructive materials of the age of technology, he has always been anxious to endow the constituents of his art with aesthetic and spiritual qualities —in fact with a soul. The *Linear Construction* in plastic (**plate II**) is not therefore a soulless object, but an artifact whose existence is justified by the beauty of its own aesthetic. Whereas the artists of the *art nouveau* style employed and adapted to aesthetic ends nature's line of life, the abstract and constructivist artists of the first quarter of the twentieth century employed and adapted the 'life-line' of technology and modern technological materials. All the Gabo drawings which illustrate this note on the sculptor exemplify the new aesthetic; that which superseded and reacted against a figurative concept, doomed to extinction by the close of the nineteenth century. The new vision was activated by a number of energies, notably Cubism and Futurism, and the sculptor was closely affected by the dynamism of these new movements. *The Technical Manifesto of Futurist Sculpture*, issued by the Italian sculptor Boccioni in 1912, states a philosophy for the revitalization of the art of sculpture. The core of his philosophy was the insistence that the new sculpture must be based upon a system of interpenetration; the interpenetration of planes. 'Not only in the construction of the masses, but in such a way that the block of the sculpture will contain within itself the architectural elements of the *sculptural environment* in which the subject lives'. Boccioni's statement was certainly known to Gabo who, from the outset of his work, has been passionately concerned with the interpenetration of planes and with the replacement of static masses by dynamic form.

Gabo has never subscribed to the idea that art can be absolutely linked with functionalism ('Either build functional houses and bridges or create pure art, but do not mix the two' he once stated), or to the idea of any reconciliation between the polarities of art and politics. 'Art is not a political instrument'. Nevertheless the few vital years which followed the October revolution of 1917 intensified also a revolutionary fervour in the arts, and it was during this vigorous and immensely creative phase of Russian history that their artists evolved the Constructivist system. Its influence was to spread far and wide beyond the limits of Moscow. But later, as this pure, untramelled fervour died away and the State began to take an interest in the nature and direction of the arts (Tatlin in desperation tried his hand at designing workers' clothes and a variety of functional objects—furniture, pottery, etc—

NAUM GABO
(1890—)

acceptable to the rise of doctrinaire Communism, while Malevich degenerated into a third rate figurative painter), Gabo disengaged from a system abhorrent to him and in 1923, with his brother Antoine, went into exile in Berlin where he was to remain for the next ten years.

Gabo has always shown a marked interest in architecture, designing in 1919 a project for a radio station at Serpuchow (95), and in 1931 a project for a theatre auditorium. 'The constructive principle leads into the domain of architecture', he declared; 'It is now the spiritual source from which architects will draw.'[1] He was right in this assumption, as the best examples of contemporary architecture clearly show. But Gabo's interest in, and association with, architecture remains peripheral. His primary objective as a sculptor—and as a draughtsman—has been to demonstrate the immense possibilities of the non-figurative idiom, especially when linked with technology, at a moment in the history of the visual arts when to stress the possibilities of the non-figurative was a genuine process of creative evolution. In strengthening Boccioni's concept of the validity of the interpenetration of planes (itself a creative extension of Cubism and Futurism), by his insistence upon the freedom of the arts, and the establishment of an entirely new dimension of the constructive abstract, Naum Gabo will stand as one of the great pioneers of modern art. He was a prophet into the bargain; his *Kinetic Sculpture* of 1920, involving a steel spring vibrating in space, was a significant gesture, foreshadowing the era of Kinetic and Optical art into which we have lately moved. Beginning his work with constructions in iron, celluloid, metal and glass, Gabo turned later to lightweight synthetic substances, particularly transparent plastics and nylon. With such materials he has been able to capture space and render it visible. 'We call ourselves Constructivists because we no longer paint our pictures or carve our sculptures, and because both are "constructed" in space and with the help of space.'[2]

Lightness, transparency, a spiritual grace, and a brilliant adaption of the 'lifeline' of technology—the actual and the metaphoric—these are the essence of Gabo's achievement. These qualities, as well as his preoccupation with the creative imprisonment of space, are all demonstrated as finely and absolutely in his drawings, as in the elegant and gracious constructions which they portend. So intimately are Gabo's drawings related to his sculpture that one must see them, not so much even as drawings, but rather as the delicate, fragile shadows cast by the translucent network of the actual forms themselves.

[1] *Constructive Art*: an exchange of letters between Naum Gabo and Herbert Read. *Horizon*. Vol. X, No. 55. July 1944
[2] *Abstraction—Creation*: Naum Gabo. Paris 1932: *Circle*, London 1937

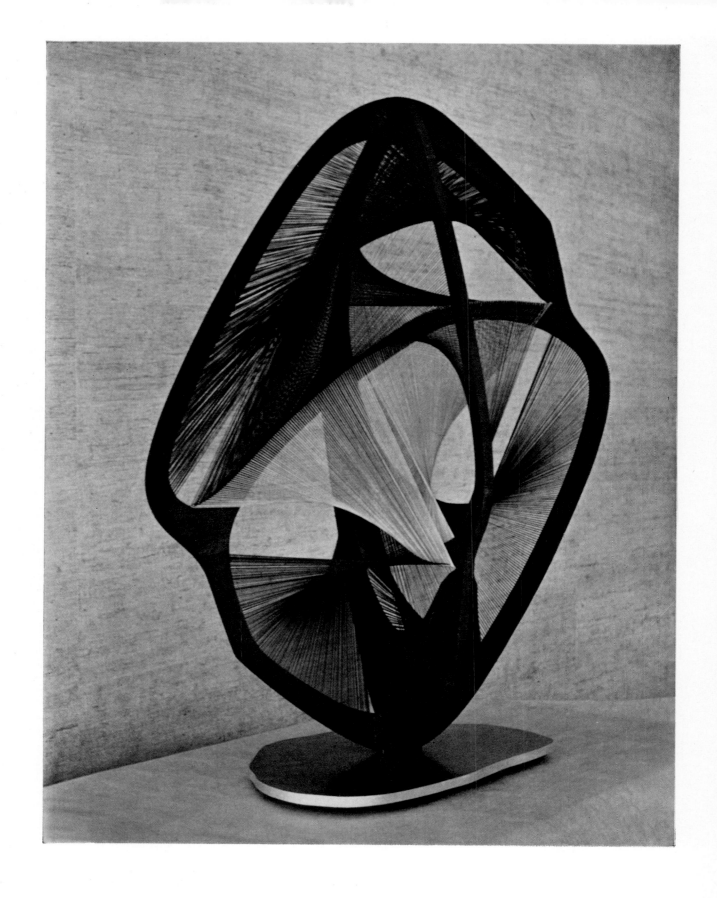

Plate II NAUM GABO: Linear Construction No 4 (with black), 1962

91 Costume sketch for 'La Chatte', 1926. *Crayon*

92 Drawing for a constructed head, 1916. *Pencil*

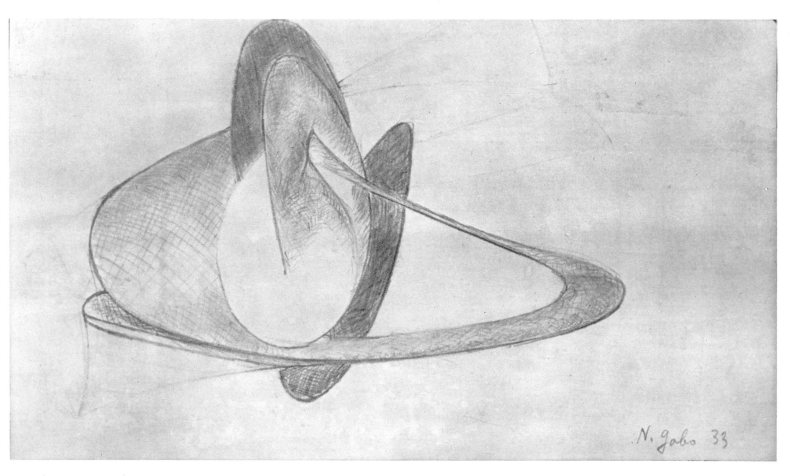

93 Sketch for a stone carving, 1933. *Pencil*

94 Sketch for spheric theme, 1935–37. *Blue crayon*

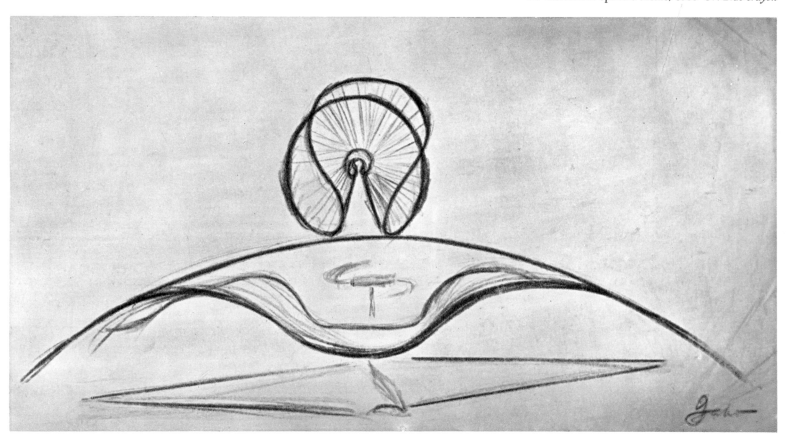

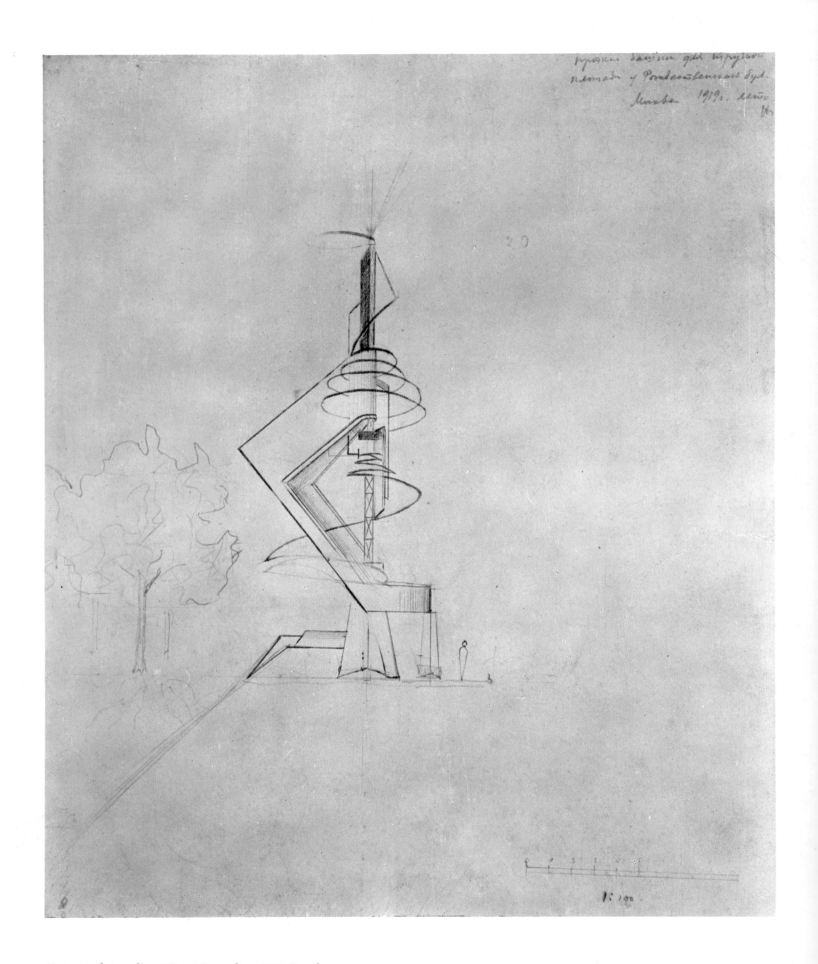

95 Design for a radio station at Serpuchov, 1919. *Pencil*

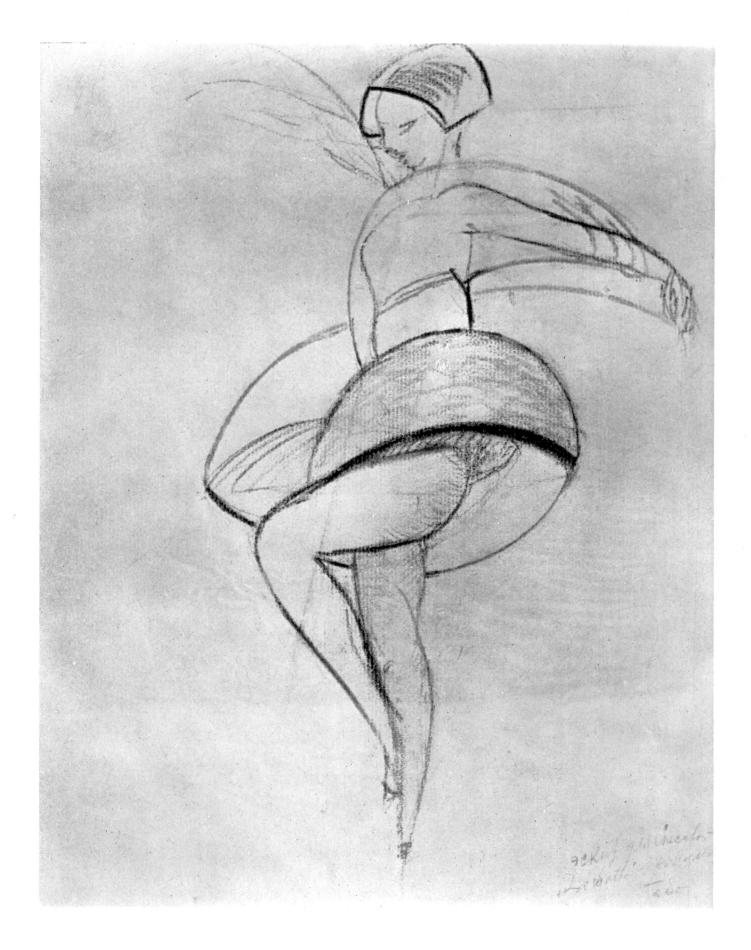

96 Costume sketch for 'La Chatte', 1926. *Crayon*

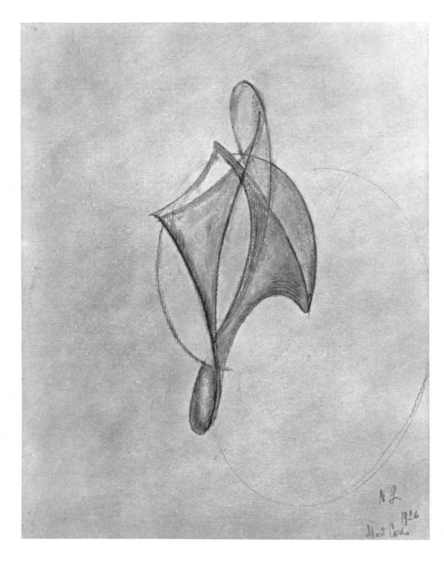

97 Monte Carlo, 1926. *Pencil*

99 Sketch for an arch, 1952.
Pencil and watercolour

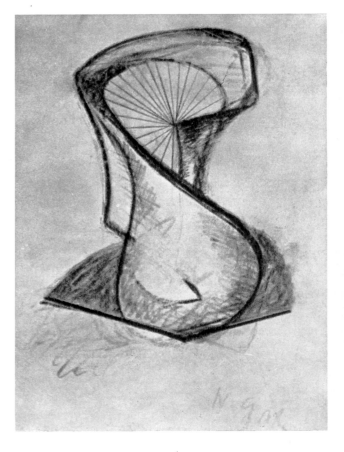

98 Sketch for a carving, *c.* 1937. *Crayon*

110

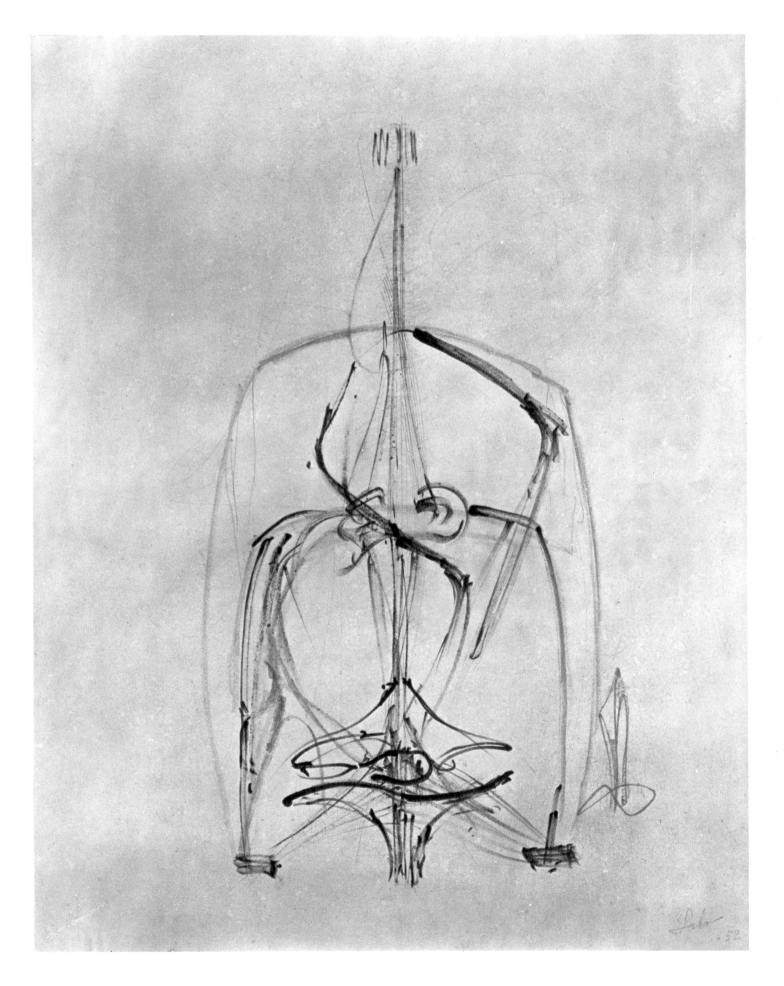

111

HENRY MOORE

(1898 –)

THE CRUCIAL problem of Moore's art is the perennial striving to neutralize the concept of the human being as 'individual' while retaining intact the idea of an impersonal, yet always anthropomorphic monumentality. This means that the artist has been able to diminish the dark side of human personality, its egoism, and cupidity, and so concentrate upon those qualities of dignity and serenity which are the better half of *homo sapiens*. Moore's drawings have played a dominant part in the shaping of his sculptural destiny as one of the supreme humanists of modern art. They are the vital thread upon which hang all his sculptural concepts. From the life drawings of his years at the Royal College of Art and immediately afterwards (**100, 101**), right through to the near abstract, though always anthropomorphic forms of the 1960's (**103**), his drawings reveal an unparalleled consistency and single-mindedness.

A central problem has been the artist's need to reduce, in particular, the 'personality' of the face, focal point of the rapacious and devouring egoism of man. We can study the evolution of the cancellation of this aspect of personality in such drawings as the *Standing Nude* of 1927 (**100**), and the *Standing Figure* of 1928 (**101**). The problem of the face has always been a critical one for the sculptor, and he has resolved it in a variety of ingenious ways, from the creation of primitive style symbolization (**102**), to the establishment of such unique stylizations as the flattened head which rises, almost unwillingly, from the impassive monument of the body in the *Seated Figure* of 1930 (**105**).

I have chosen a maquette of *The Family* (1944–45) (**108**) as the sculptural achievement which it seems to me most profoundly demonstrates everything for which Moore has striven, both as sculptor and as philosopher. The single-mindedness, in fact the very narrowness of the sculptural outlook, leads more easily and naturally to the serene contemplativeness of philosophy, than do the ragged fires of the painter's many and diffused interests. Sculptors are the philosophers of art, and Moore is no exception. *The Family* is also a work which can be easily and simply related to the huge volume of drawings which lead up to, and later away from, this quintessential core of achievement. Here is reposed the elemental concept of monumentality, of impersonality, of abstraction even, and the whole idea of the significance of the family unit which is the focal point of Moore's view of the human situation: man as part of Man; the concept of wholeness as the over-riding clue to the true meaning of man's role in the scheme of things. And always with the proviso that the parts acquire a greater and deeper sense of dignity from their relationship with other parts. Whenever Moore has related two or more figures, the sense of 'family' has been the qualifying consideration. It applies no less to the relationship of abstract forms (**107**).

But it is in the shelter drawings especially, with their marvellous feeling for the

sharing of common experience, that the inevitability of Moore's sculptural destiny is most wonderfully revealed. It is seen not only in the crucial monumentality of his vision and the power of his philosophical serenity, but also in the formal aspect of the drawings themselves. It is one thing for the sculptor to make drawings which portend stone or bronze. It is quite another, and a more astonishing achievement, for the sculptor to have realized in his drawings so profound a degree of sheer monumentality that the very act of carving or modelling would be superfluous to this expression. It were as though in wandering through the caves and labyrinths of the shelter drawings we can enter the very act of creation. But even the historic and humanitarian aspect of the subject-matter is largely irrelevant to the greater sense of purpose which these drawings disclose. They provide the perfect opportunity for the sculptor to pursue and evolve his concept of monumentality, and the relationship of units; the family of related forms. The humanity and the philosophy are implicit in the grandeur of this conception, and in this respect the shelter drawings compare, *as sculpture*, with the Sistine Paintings of Michelangelo, for these also are perfect prefigurations of a sculptural destiny.

HENRY MOORE
(1898—)

Since the 1950's Henry Moore has been moving steadily towards a closer awareness of the possibilities of abstraction; though always in a controlled and carefully modified form, so as to preserve intact the unassailable validity of the human form. In this sense his later art can be compared with that of Picasso. Neither artist has ever thrown overboard the idea of the human image, although whereas the modifications and the elaborations of Picasso are frequently violent and satirical, those of Moore are always cold and serene. In the drawing *Two Standing Figures*: 1961 (**103**), we can study the increasing awareness of abstraction, especially in the textural aspects of this work. Qualities of textural abstraction have been frequently achieved in the technique employed in making the shelter drawings—pen-and-ink and water-colour washes with chalk dragged over the surface of the drawing create a textural identity of the most subtle and evocative character. The use of chalk as a vital element in the process of establishing a textural identity for his drawings is paralleled in the textural qualities of the artist's later sculptures.

In the form on the left in the drawing of *Two Standing Figures* we can see how far into abstraction the sculptor can move without losing touch with the fundamental concept of humanity from which his whole *oeuvre* evolves, and in which, abstraction apart, its ultimate significance rests. The large mushrooming head, bursting from the spouting power of the neck, and scratched with a pattern of hieroglyphic markings, might also symbolize a loss of self, and a pondering of self, a negation of being, and a coming into being. It is a neat mid-twentieth-century parable.

So completely do the drawings of Henry Moore prefigure the extensions of his art into the actual forms of sculpture, that he, perhaps of all the artists in this study, most clearly demonstrates how purely, tightly, and totally a great sculptor can think. There is no wastage in the drawings of Moore.

100 Standing nude, 1927. *Chalk and wash*

101 Standing figure, 1928. *Chalk and brush*

115

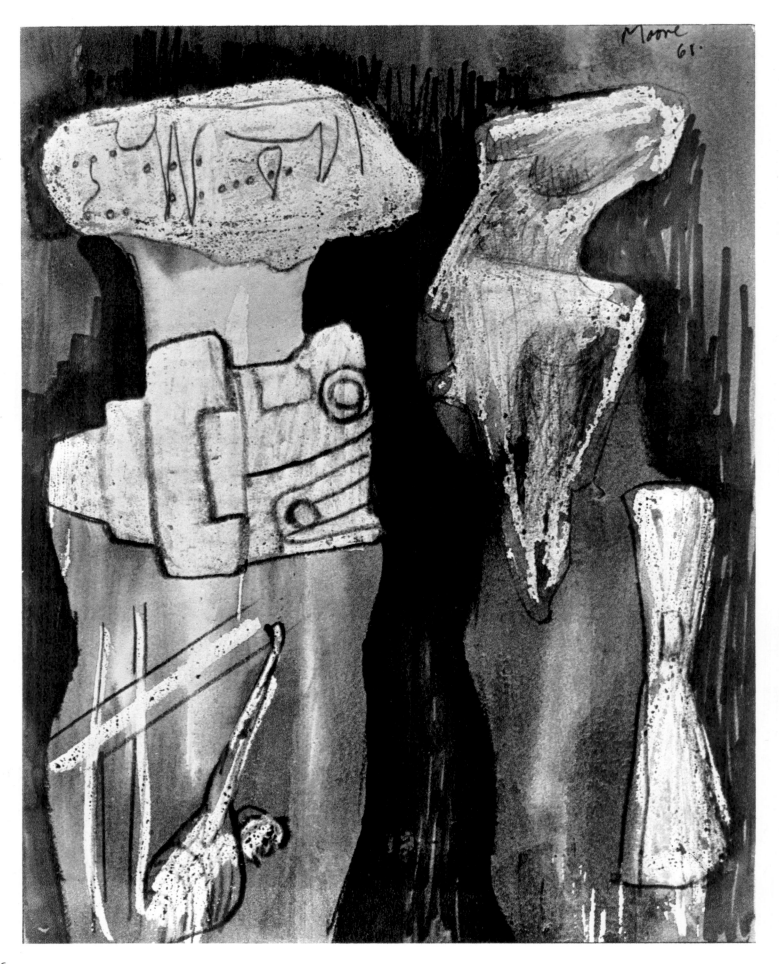

116

103 Two standing figures, 1961. *Gouache*

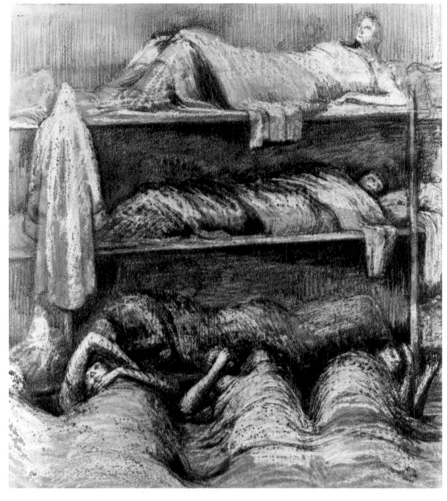

104 Shelter scene: Bunks and Sleepers, **1941**.
Pen and ink, watercolour and chalk

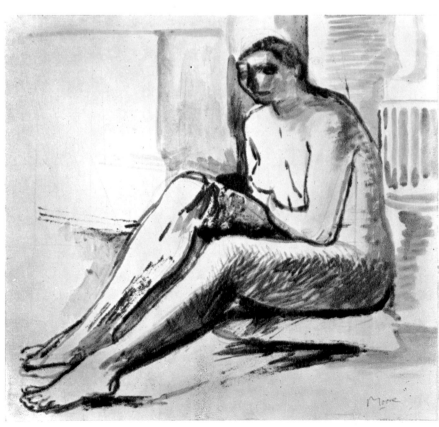

105 Seated figure, 1930. *Ink and wash*

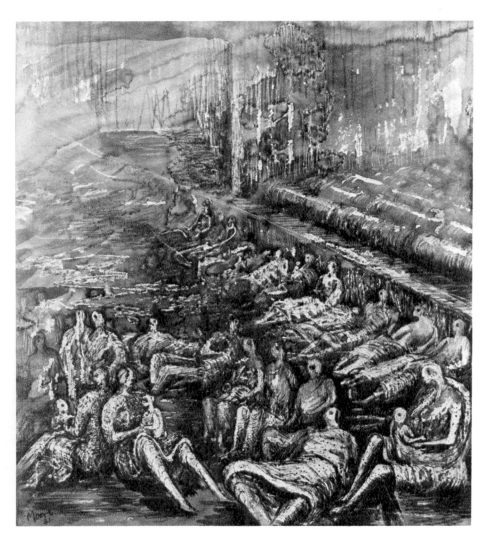

106 A Tilbury Shelter Scene, 1941.
Pen and ink, watercolour and chalk

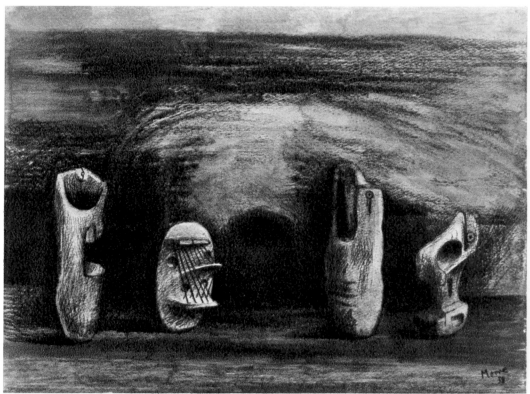

107 Four forms, drawing for sculpture, 1932.
Chalk

118

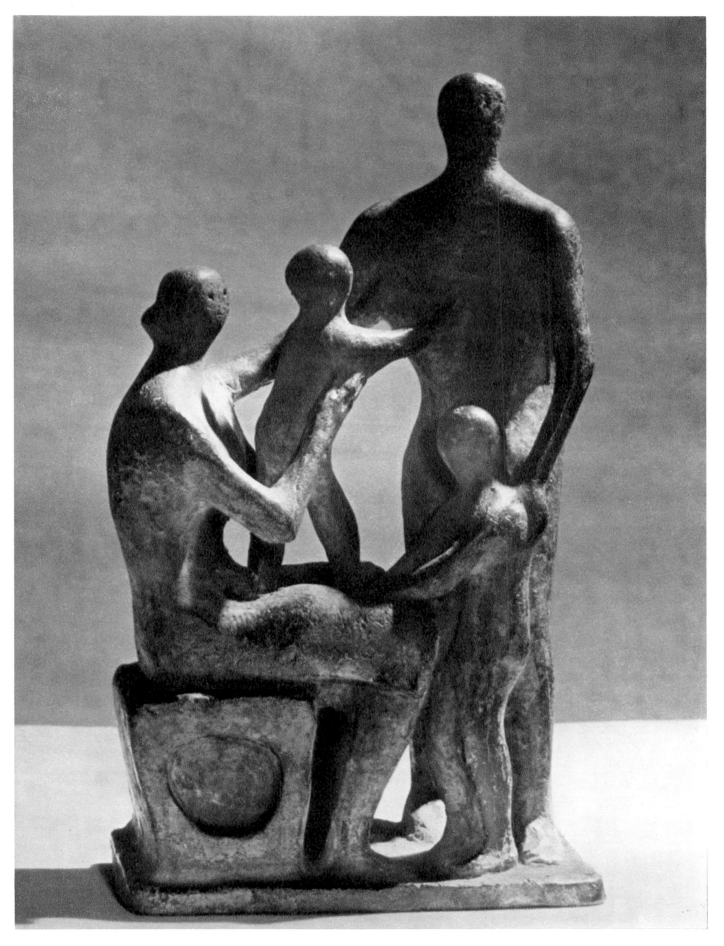

ALEXANDER CALDER

(1898 –)

ALEXANDER CALDER has made a unique contribution to the history of modern sculpture: he has divested volume of its weight; the traditional heaviness of sculpture is dissipated. From his hands float lightness and weightlessness. Where other sculptors have concentrated on monumentality, on the weight of volume, Calder has allowed his sculpture to rise up, to soar in a state of exuberant ballooning. And he, more than any other sculptor of our time—Gabo not excepted—has made use of space, not as another dimension of volume, as a foil for the bulk of stone or bronze, but as an atmosphere in which his delightful constructions are set adrift. Space is as important here as is water to the fish and marine vegetation that rise and float, billow and stream in their element. Space is the liquid ambience in which Calder releases his objects. He is the sculptural kite-flyer. His drawings convey the same sense of easy, bouyant floating away, as in *Meadow Grass* (**109**), a title which is really of little importance. Like the poet who finds a word or a phrase from which he evolves a much larger concept, while preserving a title which bears only a partial or initial relationship to the end product, so Calder's starting points are frequently left far behind, or widely extended. *Meadow Grass* is one such instance.

Sir Herbert Read suggests that Calder's art belongs to 'the realms of play'; that his mobiles are products of 'that *play instinct* which Schiller identified with the essential freedom . . . of the work of art.'[1] It is a plausible line of thought. Many artists of our time, notably Picasso and Miro (with whom Calder was in close contact during the years 1929–32), have exercised their 'essential freedom', their right to produce at times an art which is exuberant, gay, and essentially lightweight in character. A 'play' art, festival, un-serious in content, lacking only an atmosphere to match its mood—for example, the fairground, the theatre, the school. Looking at the 'play art' of Picasso, Miro and Calder set in the 'serious', sterile and purposeless isolation of great gallery displays, it has often seemed to me that what such works lack most of all is a living context. They should be part of the background for fun-fairs or gala days. There is a place for carnival art, and these are the masters who could fulfil such a need.

Looking at Calder's *Sun Face* (**110**), his *Head* (**114**), or the mobile, *Lone Zig-Zag* (**111**), what strikes one is the sense of sheer *fun* with which the artist endows his work. It is a mood, an atmosphere which stems at least partially from Calder's frequent visits to the circus during the period 1926–27. At this time he was stimulated to construct a miniature circus peopled with figures made of wood and wire, and to this period also belongs the evolution of his technique of suggesting form through movement. Calder's earliest mobiles (the term was invented for him by Jean Arp) were based on mechanical motivation, after which he progressed towards free organic movement as the source of action. Currents of air, vibration, a breath of

wind, these gentle forces and pressures were the point from which the flat, two-dimensional shapes of his art began to carve out their orbits of three-dimensional form. Carola Giedion-Welcker in her book *Contemporary Sculpture* (mcmlvi) neatly summarizes the fundamental character of Calder's art: 'The progenitors of his art are those airy constructions that revolve on roofs and church spires. Their movement is borrowed from the wind, their existence airy and playful.' The basis of such sculpture is the world of flat shapes which he explores so dexterously in his drawings. No sculptor has devised a more unique and personal vocabulary of sculptural elements than Calder (112). Materially, his art is simple. Painted shapes of wood and metal (sheet-iron and tin), wires and slender rods. His drawings are about arrangements of shapes and wires—or rods. And about movement. The *Head* (114) gyrates, vibrates; the *Nest* (115) spins, and the spots revolve like planets; the Miro-esque *Black Stars* (116) is a rapturous pattern of activity like the swirl of wet sand as the thick liquid is stirred with a naked foot and pebbles, shells and a host of little creatures are set in a drifting motion.

ALEXANDER CALDER
(1898—)

The idea of movement is, of course, synonymous with the lightening of weight. Volume remains, and form, in the arcs of movement described by the sculptor's mobiles. They occupy and fill space, but only as a field of corn waving in the breeze, or a tracery of shadow cast by a leafy tree on a sunny day occupies and fills space with the volume of its undulating movement. Calder's drawings are a preparatory shedding of weight. We know that even the black shapes will be translated into thin, light materials. The feathery shape on the left in the drawing (117), the whorl of wiry line on the right are weightless; the 'heaviness' of the rendering is purely a decisive exploration of shape and movement. So close is the relationship between Calder's drawings and his sculpture that we feel it is only necessary to cut out the elements and assemble them in a three-dimensional form. Picasso once said that if one could cut up certain Cubist paintings—those which analyse the plastic aspects of form—they could be re-assembled as sculpture. Calder's drawings are of a different order, creating rather than analysing form, yet the idea of their re-assembly as sculpture is apparent. What his drawings also reveal is the extensive, though in the end severely modified, use the artist makes of his two primary sources of inspiration—nature and the machine. Though his sculpture clearly belongs to the mechanical age, the shapes are derivative from the forms, rhythms, and organic impulses of nature. Technically, their acute delicacy reflects both the fragility of nature and the precision of the machine. It is this masterly fusion of the natural and technical orders—of the organic and the mechanical—which gives the artist his special place in the art of our time. He is the most subtle of humanists; having made his peace with the age of technology without ever losing sight of his identity as a human being. His drawings are the roots of this reconciliation.

[1] *A Concise History of Modern Sculpture*: Herbert Read. Thames & Hudson. Page 162

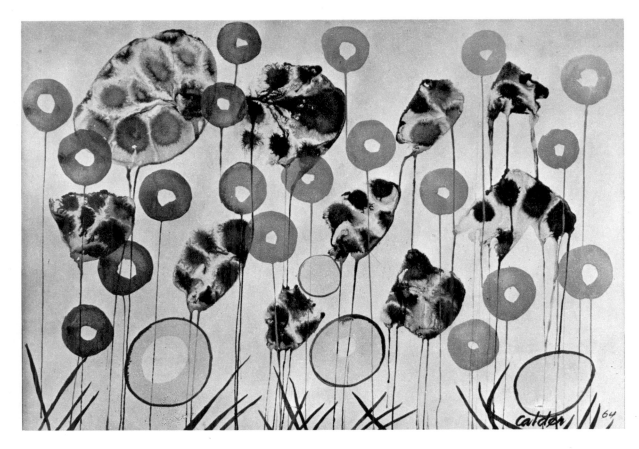

109 Meadow Grass, 1964
Gouache

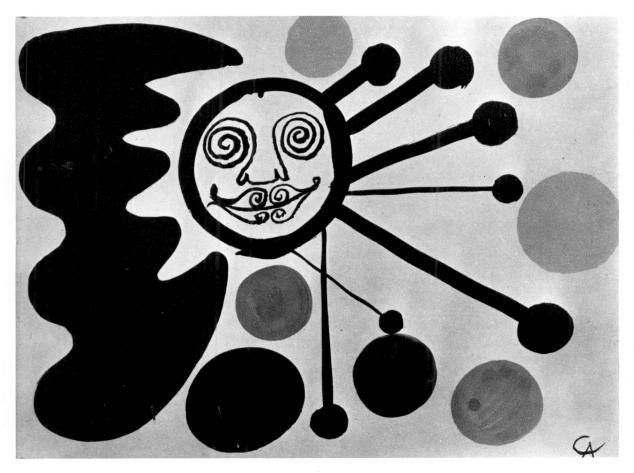

110 Sun Face. *Gouache*

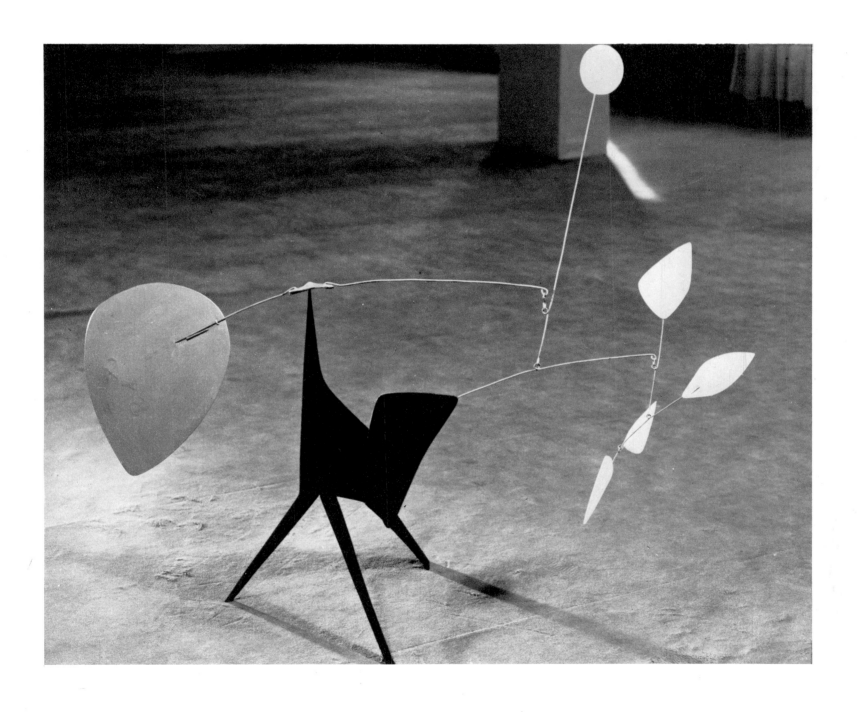

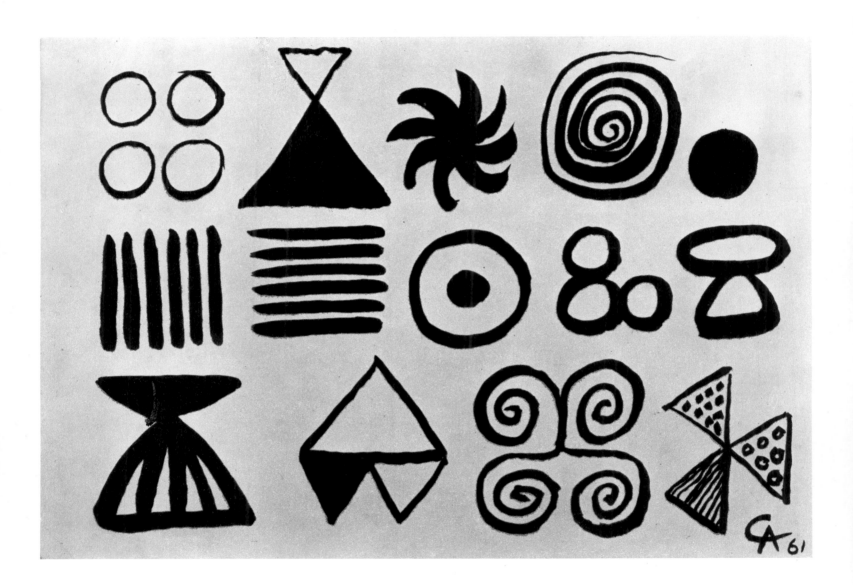

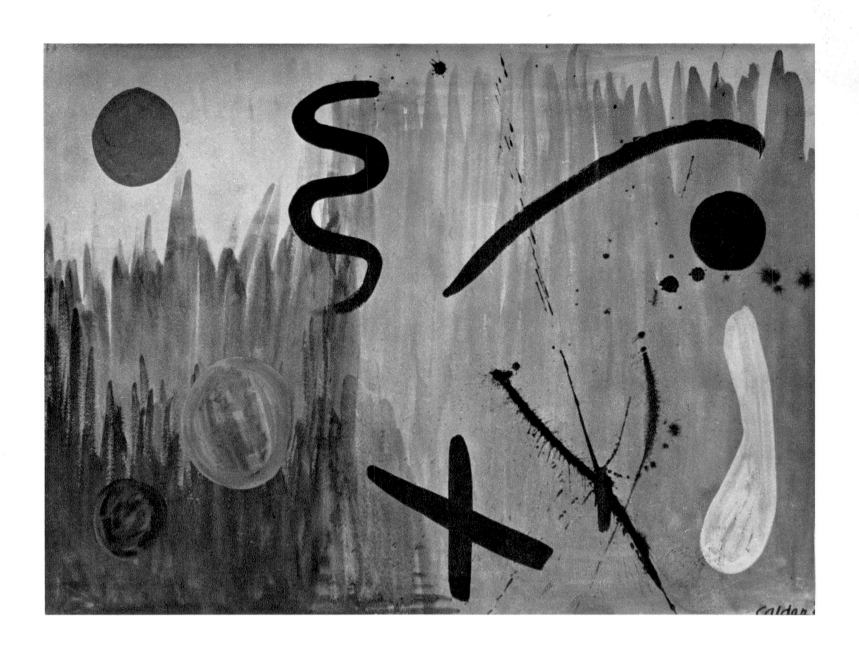

113 Composition. *Gouache*

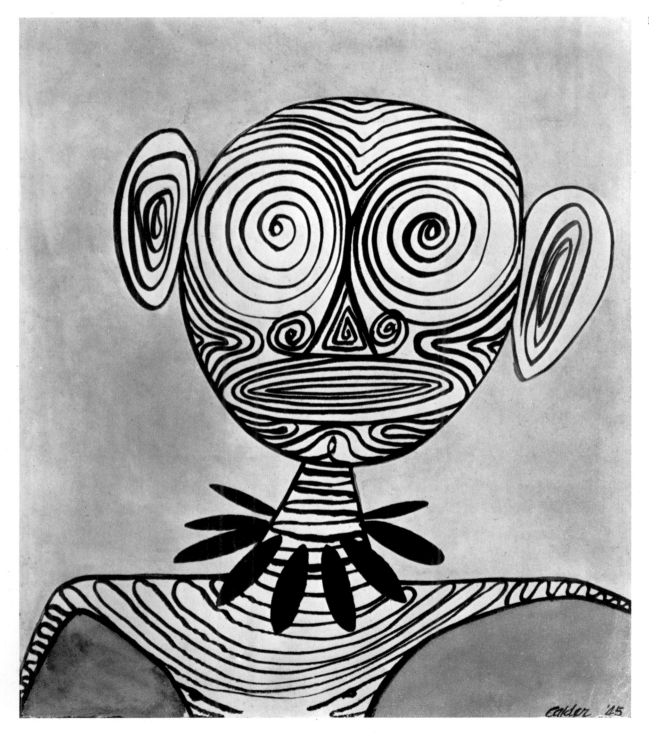

114 Head, 1945. *Watercolour*

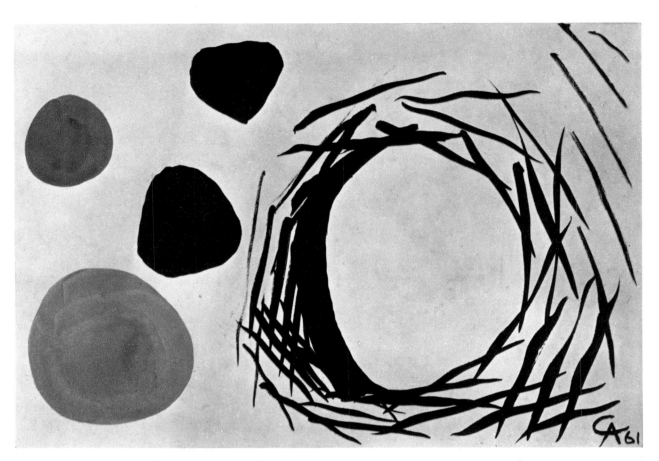

115 Nest and two orange spots, 1961. *Gouache*

116 Black Stars, 1953. *Gouache*

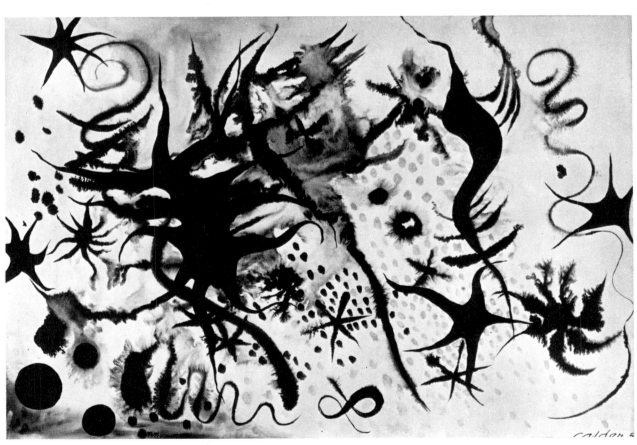

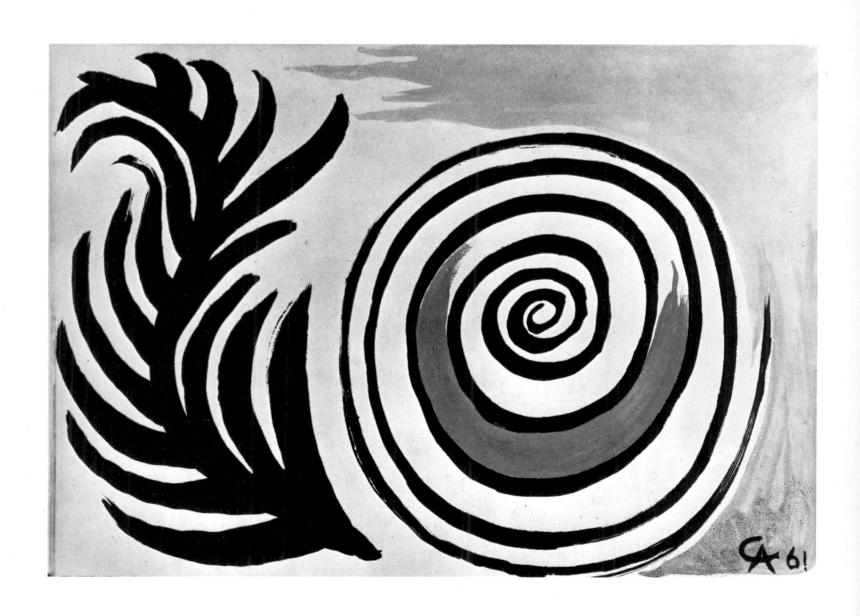

117 Composition, 1961. *Gouache*

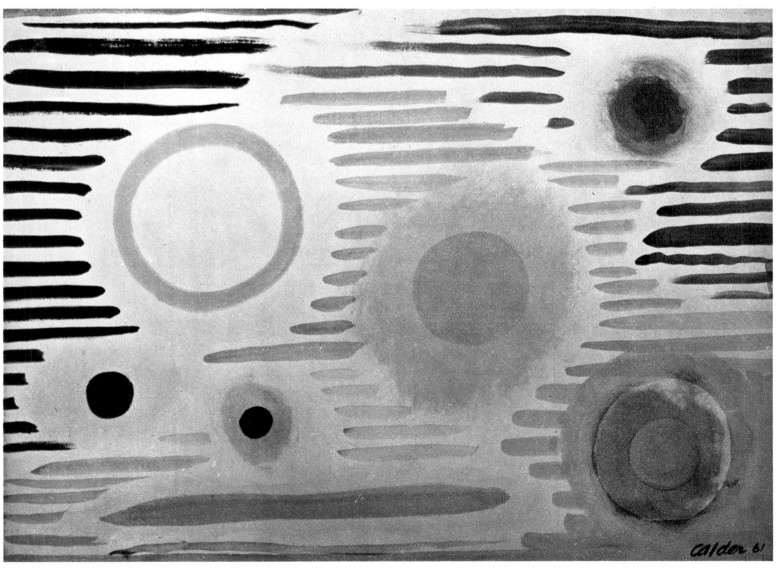

BARBARA HEPWORTH

(1903 –)

IT WOULD be difficult to think of two sculptors who are more clearly the natural complement of each other than Henry Moore and Barbara Hepworth. Between them they represent the totality of the modern aesthetic urge; the need to reconcile the provinces of abstraction with the perennial tug from the earthy roots of figuration. The one pull is esoteric, the other instinctual. Hepworth has settled largely for the former, Moore for the latter. Both artists were born in Yorkshire, Hepworth in 1903 at Wakefield, and Moore at Castleford in 1898. They were students together at Leeds College of Art, and later at the Royal College of Art in London. For both artists, drawing has been the mainspring of their sculpture. Yet in spite of many similarities, conceptual, technical and stylistic, they have chosen to move in opposite directions. Whereas Moore has never given himself wholeheartedly to the problems of creating a purely abstract *oeuvre*, Hepworth has finally emerged as a dedicated and consummate exponent of the abstract vision. It is a fact not without complexity, or paradox, since those drawings of hers which have been made direct from the human form, or from human situations, such as the remarkable series of hospital drawings which she began in 1947 (these make an illuminating comparison with the shelter drawings of Henry Moore), contain a profoundly humanistic quality. The figures involved are less metaphors or symbols than comparative elements in the work of Moore. They possess a more evident, tender and moving sense of humanity. Yet the characters who appear in this series are not 'individuals' in the crude sense of the word. They are above all graceful, a quality echoed throughout the whole of the artist's work. Time and again in her drawings and her sculpture Barbara Hepworth makes it abundantly clear that grace is the dominating element, the basic condition of mind, in her concept of aesthetic order. In a statement, *Rhythm and Space*, published by Herbert Read in his book *Barbara Hepworth: Carvings and Drawings*,[1] the sculptor more than hints at this attitude of mind, as well as describing in the most tender and revealing terms the nature of her attempt to reconcile the pull of a deeply humanistic heart and a mind absorbed by problems of pure aesthetics. She is writing about her hospital studies. '. . . about the middle of 1947, a suggestion was made to me that I might watch an operation in a hospital. I expected that I should dislike it; but from the moment when I entered the operating theatre I became completely absorbed by two things: first, the extraordinary beauty of purpose and co-ordination between human beings all dedicated to the saving of life, and the way that unity of idea and purpose dictated a perfection of concentration, movement and gesture, and secondly by the way this special grace (grace of mind and body) induced a spontaneous space composition, an articulated and animated kind of abstract sculpture very close to what I had been seeking in my own work.'

This is Barbara Hepworth's testament of beauty. The drive to reconcile the human and the aesthetic, and beyond that, the compulsion to evolve an art form pure

and complete in its own right, yet owing, inevitably, its grace and harmony to a profound, sensitive and always tender study of the human form: 'With the model before one, every known factor has to be understood, filtered and selected; and then, from these elements in the living object, one chooses those which seem to be structurally essential to the abstract equivalent, relevant to the composition and material in which one wishes to convey the idea. After my exhibition in 1946 at *Lefevre* the abstract drawings which I did led me into new territory; the forms took on a more human aspect—forms separated as standing or reclining elements, or linked and pulled together as groups.'

In this context compare the *Two Figures* of 1947 (**119**) with the *Monoliths* of 1953 (**126**). Much of Barbara Hepworth's earlier work, especially much of the drawing and sculpture produced during the years she was married to Ben Nicholson and working with him at St Ives, in Cornwall, is more purely abstract in the geometrical sense, though even here, the figurative sources are easily traceable. The flat planes of the sea, the caves and rocks, the colours and shadows of a dramatic landscape, were all 'understood, filtered and selected.' The influence of Gabo also plays a considerable part in the work of these earlier years, and curiously, even in some of her late drawings, such as the *Three Monoliths* of 1964 (**125**), the influence of Nicholson powerfully reasserts itself. But this fact is more the measure of her integrity and devotion as an artist than a mere indication of her debt to Nicholson. The truths she discovered with him and through him remain, when all is all said and done, universal truths. In this sense they are neither his nor hers.

During recent years the drive towards a purely abstract vision has been the predominating theme of her work, much of which has been commissioned for public display. But the perennial roots, the drive and vision remain undaunted. Grace, even in her most completely abstract work, always springs from the study of things: the human form, the elements of nature. At the same time she reveals the nature of those abstract qualities—shape and texture especially—which are hidden within the patterns of nature. Barbara Hepworth has arrived at this truth out of her devoted study of the forms of life. Unlike the younger generation of abstract artists—painters and sculptors—who seek to arrive at abstract permutations from the crack of a starting pistol and while still in their art-school diapers—Hepworth is aware that the quest for truth must begin its journey in the most parochial back-yards of visual experience. Look at the human figure, look at a hunk of landscape, and from this humble and always devoutly conditioned act of exploratory looking, sustained over a period of years, wait for the truth, for the inwardness, for the hidden reality of things to reveal itself. In this sense her work is vision and revelation. The quintessence of the religious experience.

Like other artists of substance and quality Barbara Hepworth is always return-

BARBARA HEPWORTH
(1903—)

ing to the act and experience of drawing. Recently I spoke with her about the dominant part which drawing plays in her work. 'Periods and phases of drawing are vital' she said: 'One needs to record, endlessly, one's observations of the human form and of nature. It is from these sources that my forms derive. I often involve myself in periods of drawing from the life . . . the impulses of human life and of nature absorb me. The impulses of growth that determine the changing shape and form of living things intrigue me.' The ebb and flow of 'the impulses of growth' are mapped and charted in all their intricate and infinitely variable diversity in the drawings of Barbara Hepworth. They are the living plasma, the growth moulds of her sculpture (**plate III**).

'I am primarily a carver and therefore do not start my work until the idea is absolutely clear in my mind. I use drawing and painting for the exploration of forms and depths which lead finally to the idea of a new sculpture.'[2] The notation may be as fragmentary and flashing as the *Wave Forms* (**122**) or as complex and fastidious as the *Women with Flags* (**123**), but they are equally important as points of departure for the conceptualizing of sculptural projects. Indeed, we must consider all her drawing as a preliminary stage in the making of sculpture. And looking at her *Pierced Form* (**127**) read back from this into the labyrinths of her drawings which contain the nascent seeds of its being; the curve of the buttock, the oceanic tear in the rocks, it is all here.

[1] *Rhythm and Space*: Barbara Hepworth. *Carvings and Drawings*: Herbert Read. Lund Humphries 1952
[2] *Artist's Statement*: Barbara Hepworth. Methuen 1963

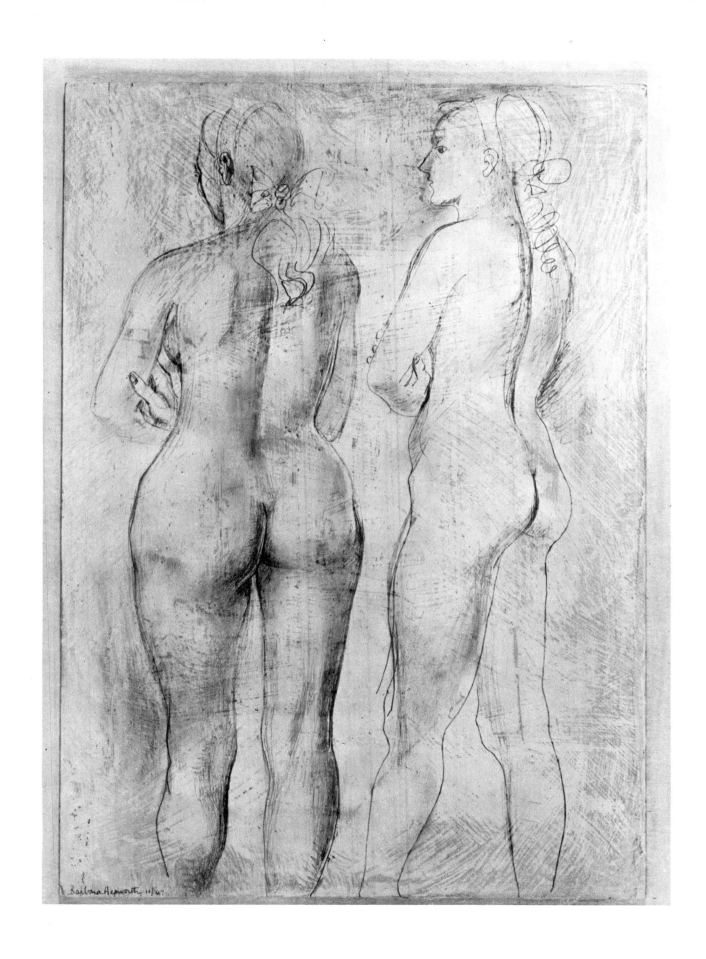

119 Two figures with folded arms, 1947. *Oil and pencil on wood*

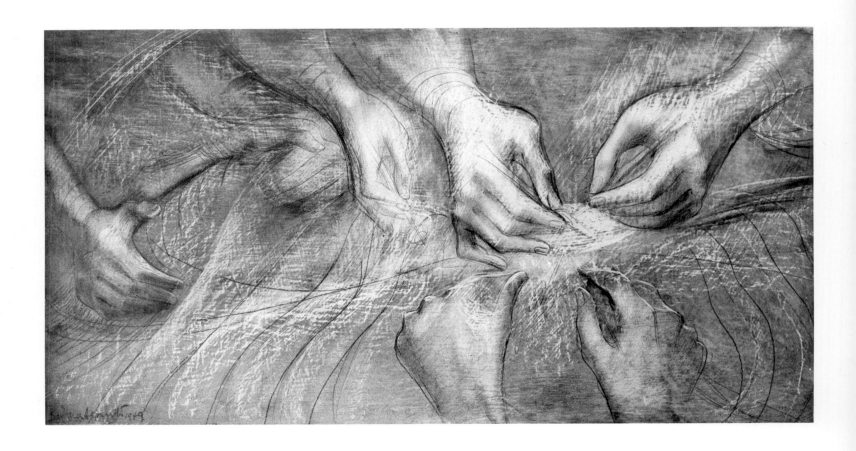

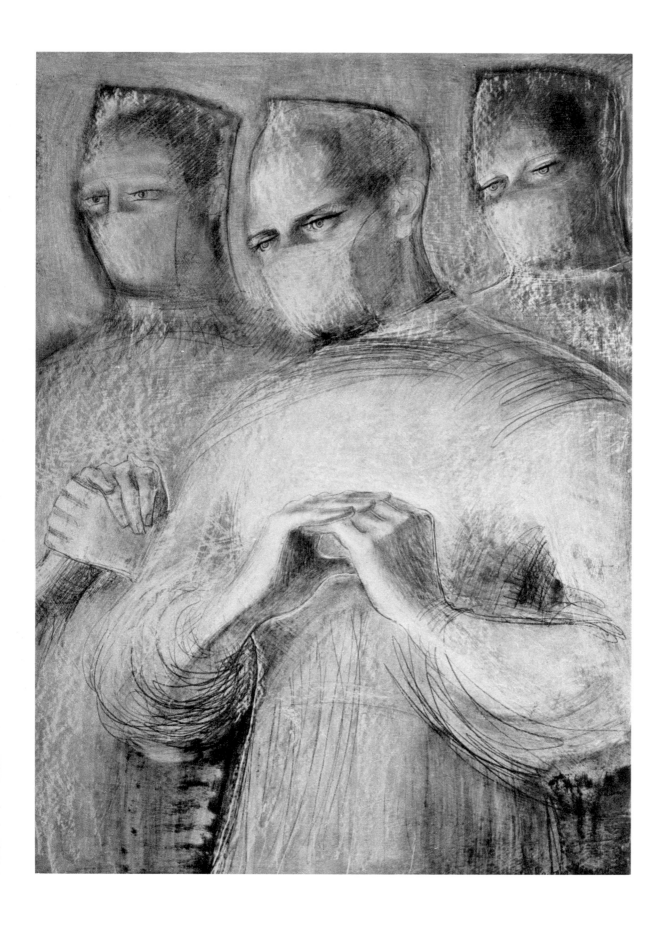

121 Skiagram, 1949. *Oil and pencil*

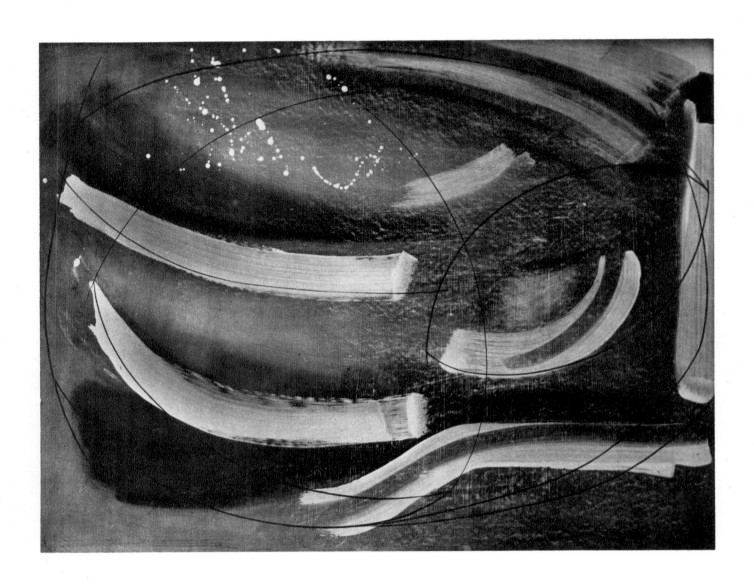

122 Wave Forms (Atlantic), 1964. *Oil and pencil*

136

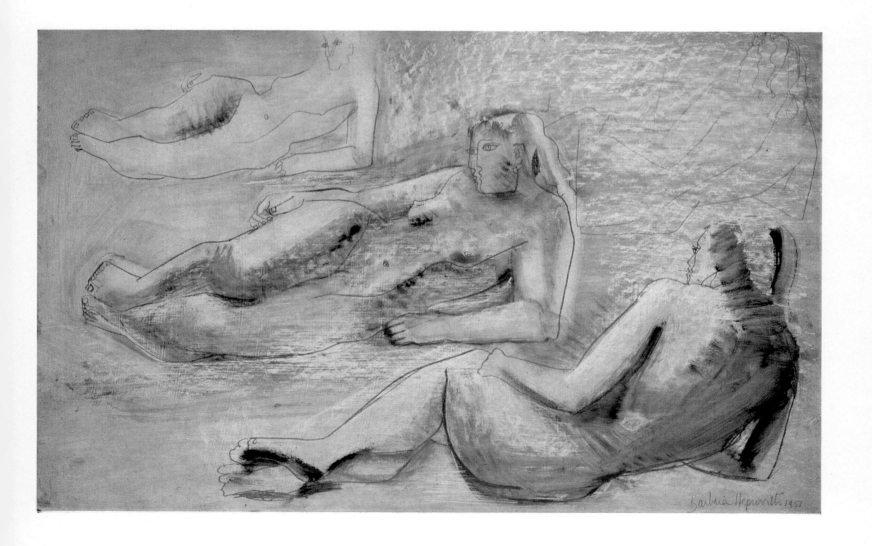

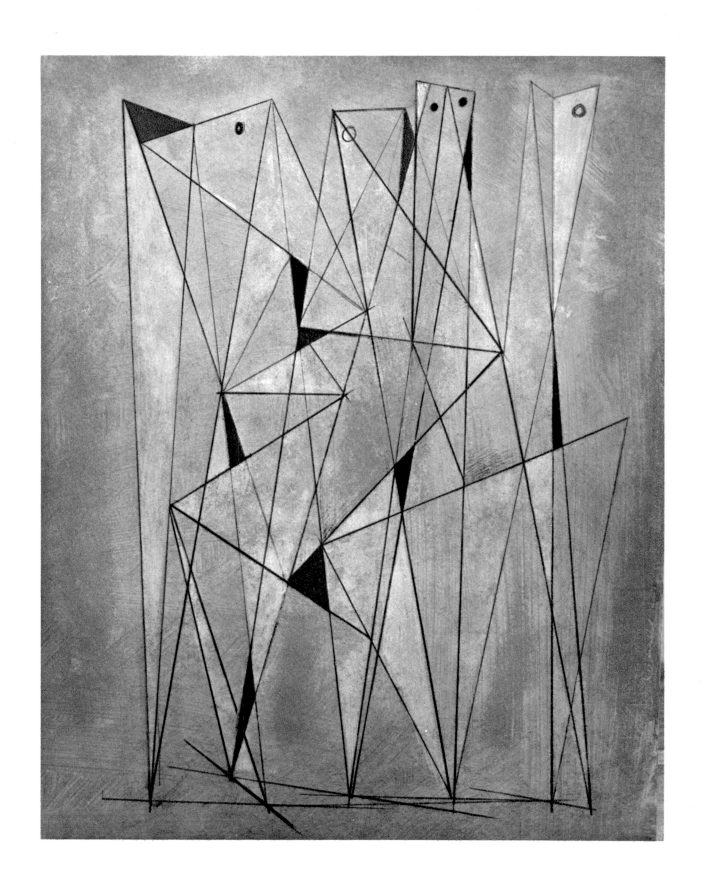

123 Women with flags, 1952. *Oil and pencil*

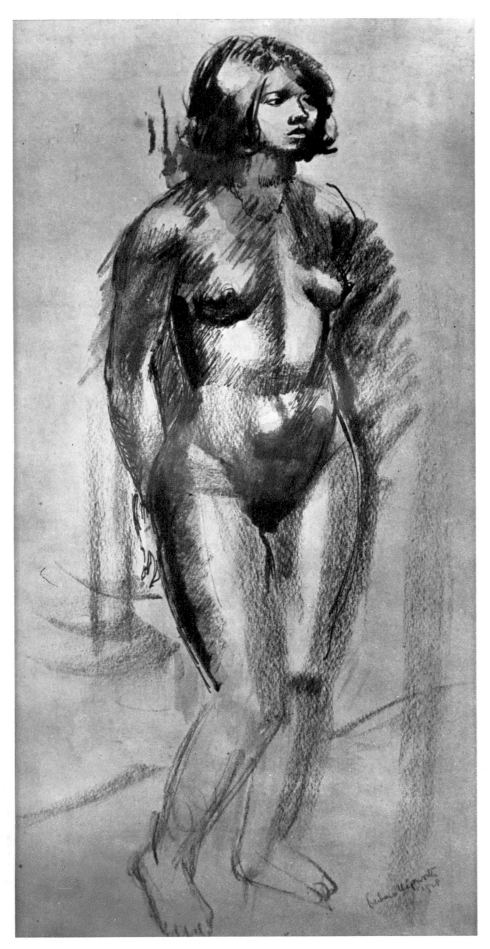

124 Standing girl, 1928. *Charcoal, crayon and ink*

125 Three Monoliths, 1964. *Oil and pencil*

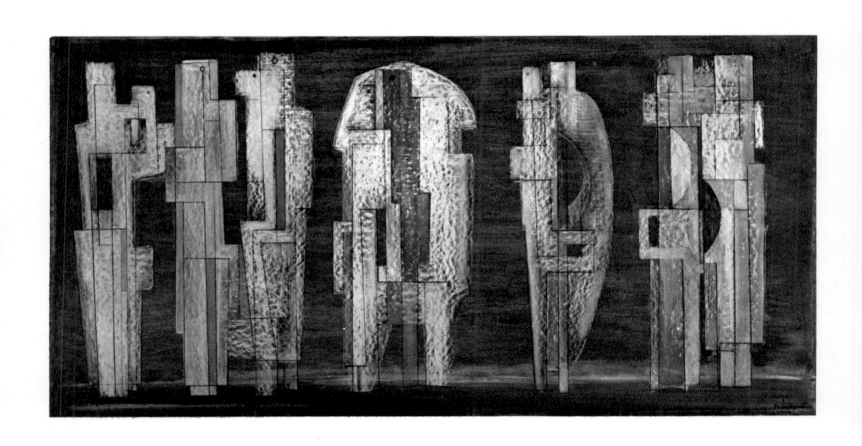

126 Monoliths (Pavan), 1953. *Oil*

127 Pierced form, 1963. *Pentelicon marble, height 50 in.*

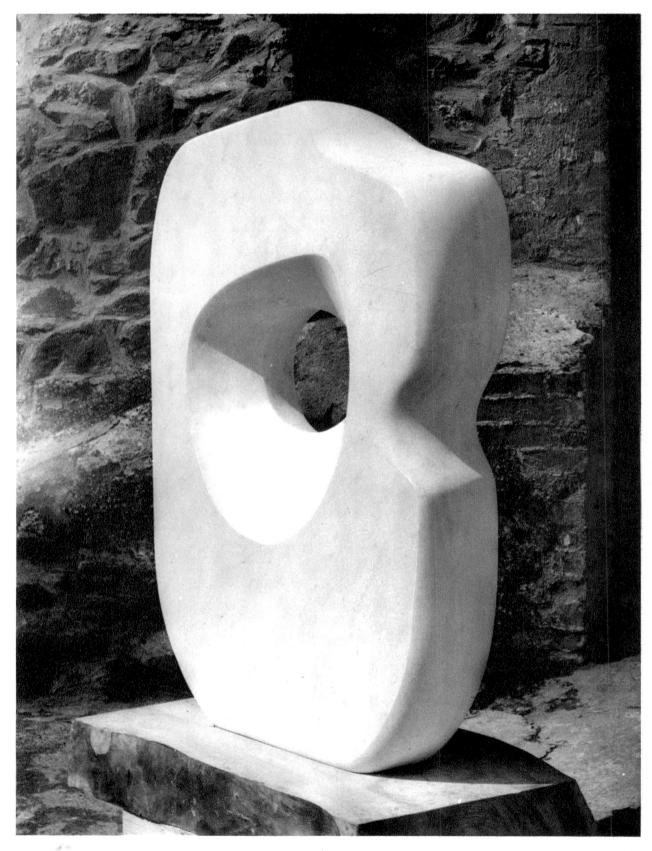

EMILIO GRECO

(1913 –)

TO HAVE resisted successfully the cajoling of an intellectual climate sunk in a squalid mess of brutalism, psycho-analytical involvements of every kind, and all the various self-indulgences which bedevil the artist of our time, is in itself no meagre achievement. And by the successful act of resistance I mean the achievement of an artist who, working outside the limits of this 'popular' climate, has nevertheless made a contribution of substance and significance to the art of his time. Such an artist is Emilio Greco. In the sense that Greco has striven to reconcile the qualities of the classical tradition with the demands and requirements of modern industrial society, I have no doubt that he is the most important of the well-known trinity of sculptors now working in Italy. Important primarily because he, more than the others, has recognized the need to provide a soulless, mechanistic, and totally materialistic era with a vision of beauty essentially humanistic, and fundamentally related—as the sculpture of classical India is related—to the idea of woman as the focal point of that beauty. In specific, though no less pointed, terms J. P. Hodin, a close friend of the artist, has described the basis of Greco's approach: 'His credo lies in the human. He believes that civility, elegance and the lyricism of art and thought can restore our lost inner equilibrium, he believes in art as a remedy for our time-bound evils, he is convinced that refinement and perfection are the signs of a mature culture, he does not resign before the onslaught of primitivism, the vulgar, the brutal, unbound passion and bestiality. His is the realm of love not of sex, his is the faith in the eternal not in the everchanging present.'[1] He is right, of course. Whereas the Indian sculptor, working in the light of the erotic philosophy of Hinduism, anchored his imagery in supremely sensual configurations, Greco's view of woman is chastened by a sense of the purely aesthetic: a looking at the body for no reason other than to perceive and document the various aspects of physical grace which continually reveal themselves to the sensitive and enquiring eye that looks with love. Greco's concept of woman can perhaps be seen as the complement of the Indian view. Both views are valid aspects of a totality. Lust, a stimulating emotion, must be balanced—in love—by tenderness; as heat by coolness, and tension by relaxation. Indeed, neither lust nor tenderness has any meaning—in terms of the love-relationship between man and woman—without the alternating presence of the other. Greco concentrates on 'the humanism, the civility and beauty, the grace, elegance and lyricism' without which any awareness and understanding of woman is incomplete. And indeed, in looking at such drawings as these here reproduced, or at the masterpiece of sculpture, his bronze *Bather* (129), we can at least initially restore something of the 'lost inner equilibrium' without which the idea of civilized existence is meaningless. Moreover, Greco helps to restore our view of woman herself. He reinvests her with the self-respect that has been stripped away by the

hideous processes of commerce. She is not just the vacuous and imbecile sex symbol of modern advertising. Her sexuality—always most potent when it is most mysterious and discreet—is balanced and offset by all manner of physical and spiritual graces, many of them revealed in the art of Emilio Greco. There is a calmness, repose, a sense of ordered tranquility about his drawings and sculptures which points away from the startling, but neurotic and ultimately destructive, forces of sensation and novelty which distinguish the lesser talents of our time. His is the art of the eternal verities.

The totality of all great sculptural talents, the consistency and dedication of vision which is common to the great sculptor makes it impossible to separate the drawings of a master from their culmination in his sculpture. This is true of Greco. Look at the study for his bronze *Bather* (128). The artist's frequent use of the pen is also a pointer to his method of sculptural thinking. The intensive and complex system with which he constructs his drawings demands a clarity of conception— always monumental in essence—and a degree of technical accomplishment which would be diminished and weakened if the artist had worked in a less exacting medium such as chalk, or charcoal. There is no woolliness about his method of sculptural thinking. In fact his pen drawings are expressions in a preliminary form of the bronzes which are their final extension into a physical third dimension. In the hands of Emilio Greco, pen and ink are the *esprit* of bronze, the inwardness of form and volume around which he thumbs the clay. These drawings are the spiritual armature of his art. No other drawing media could serve this end so well.

The Tate Gallery's collection of pen studies for Greco's monument in bronze to the author of *Pinocchio* at Cellodi, a group of which are reproduced here, show clearly how the sculptor's conception develops from the notation of rudimentary ideas into forms of drawing which are totally sculptural. In Greco's work vision and technique are superbly blended. The rapport is so harmonious and serene, that one is tempted to see his art as the logical extension of his personal origins. A native of Catania, the part of Sicily once occupied by the Greeks, Greco carries into the mid-twentieth century the destiny of those harmonies which marked the immaculate arts of Greece. There is no conflict, no *angst*, no morbidity; in fact he displays none of the repugnant symptoms of an age, once genuinely in revolt, and now tragically in decline and decay. If any artist can help rekindle the flame of balance and order, of harmony, tenderness and love, then it is Emilio Greco. Picasso once remarked that the crucial tragedy which faces the young artist today is the fact that he has nothing to react against. In an age which acknowledges no standards (not even bad ones), where all is permissible—good, bad and indifferent alike—there is no impetus for the artist to feel passionate about anything. Which means of course that he will have nothing to say. An artist like Greco, however, has reacted, but quietly and without any fuss, against the mindless cult of novelty by means of the disciplines of harmonious thinking and ordered technique; where no one can draw the good draughtsman is a revolutionary.

The *avant garde* of tomorrow will necessarily think back to the roots and sources of the European tradition. Humanism, harmony, humility in the face of the raw materials of art will determine the shape of things to come. Greco's art is a pointer to the direction this course must take.

EMILIO GRECO

(1913—)

[1] *Emilio Greco: The Earthly and the Heavenly Love.* STUDIO International, Sept. 1965

128 Drawing for 'The Bather', 1956
Pen and ink

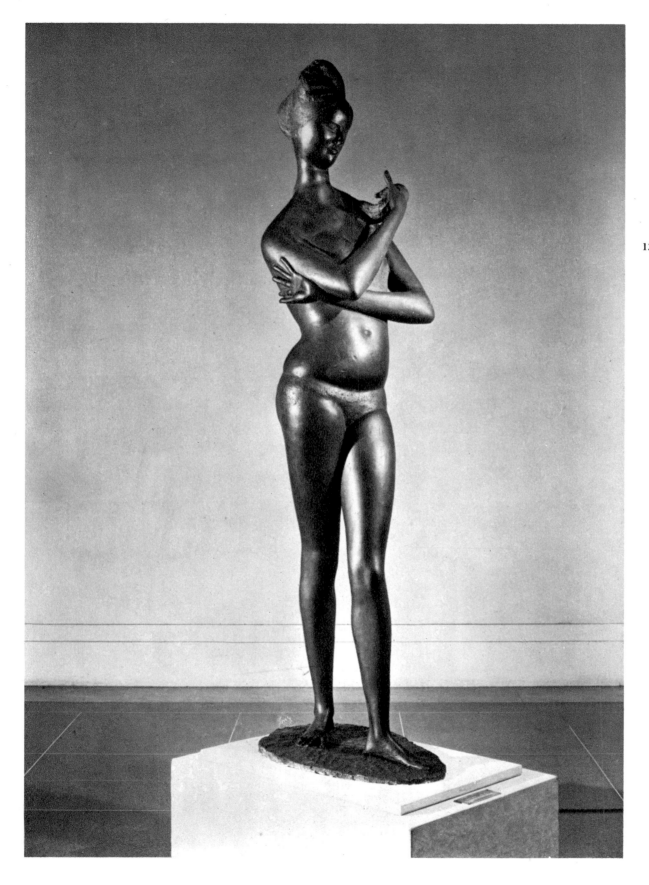

129 Bather, 1956
Bronze, height 84½ in.

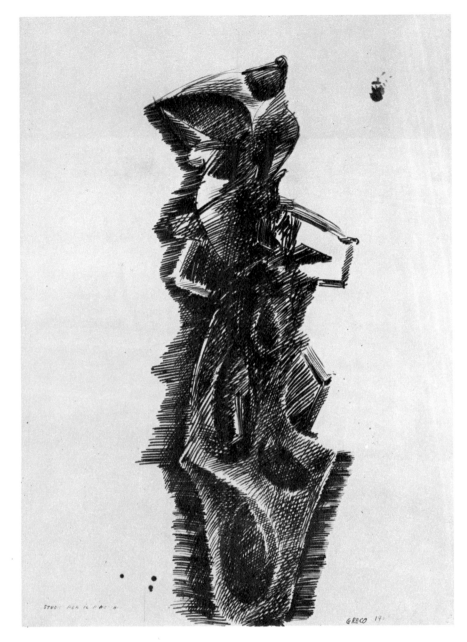

130 Drawing for 'Pinocchio', 1953. *Pen and ink*

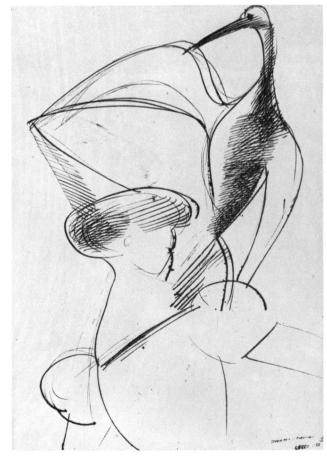

131 Drawing for 'Pinocchio', 1953. *Pen and ink*

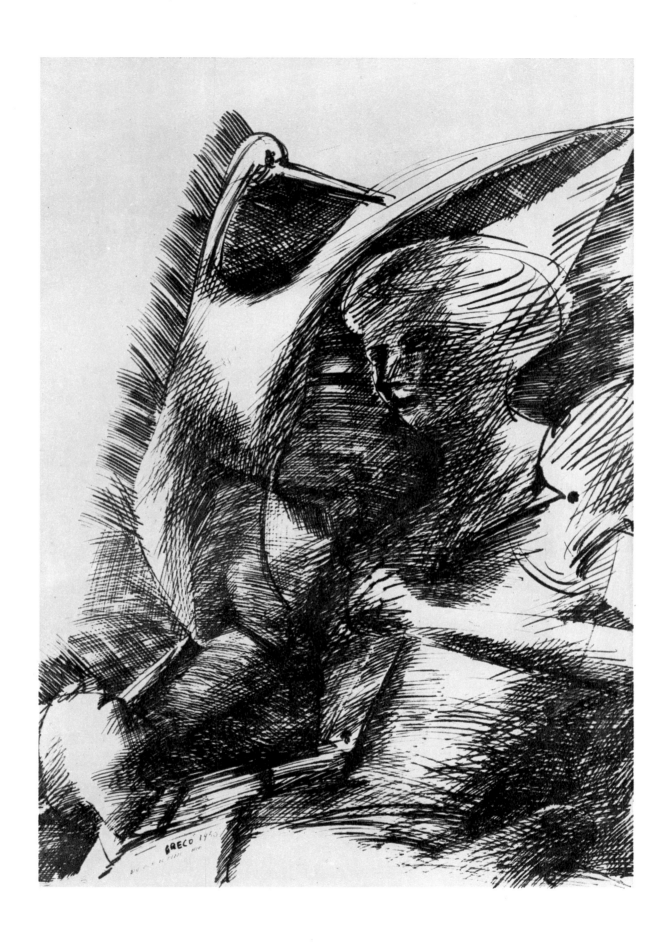

132 Drawing for 'Pinocchio', 1953. *Pen and ink*

133 Drawing for 'Pinocchio', 1953
Pen and ink

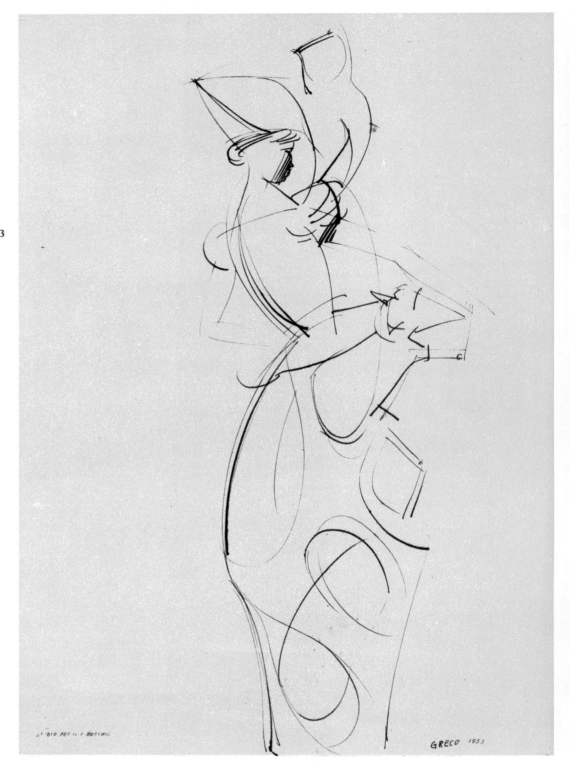

STUDIO PER IL PINOCCHIO

GRECO 1953

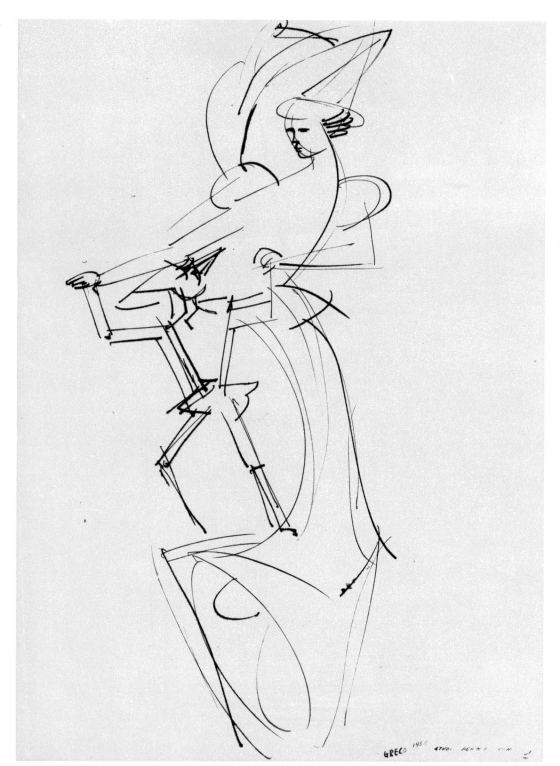

134 Drawing for 'Pinocchio', 1953
Pen and ink

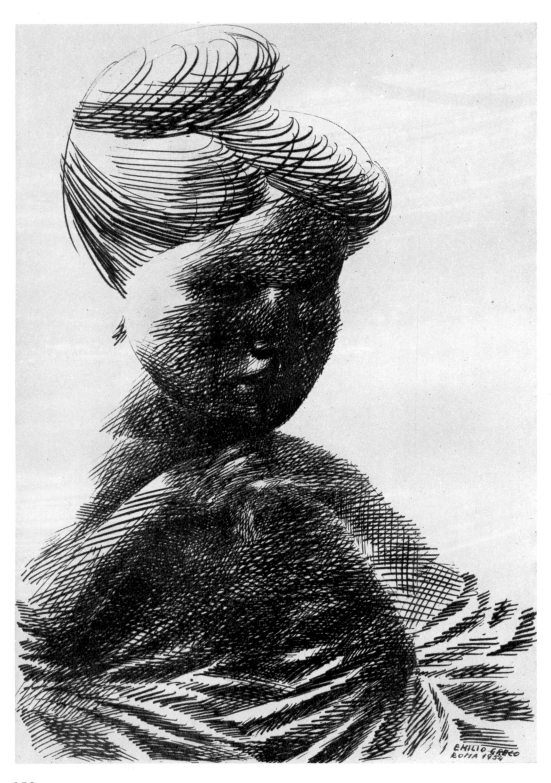

135 Head and shoulders of a girl,
1954. *Pen and ink*

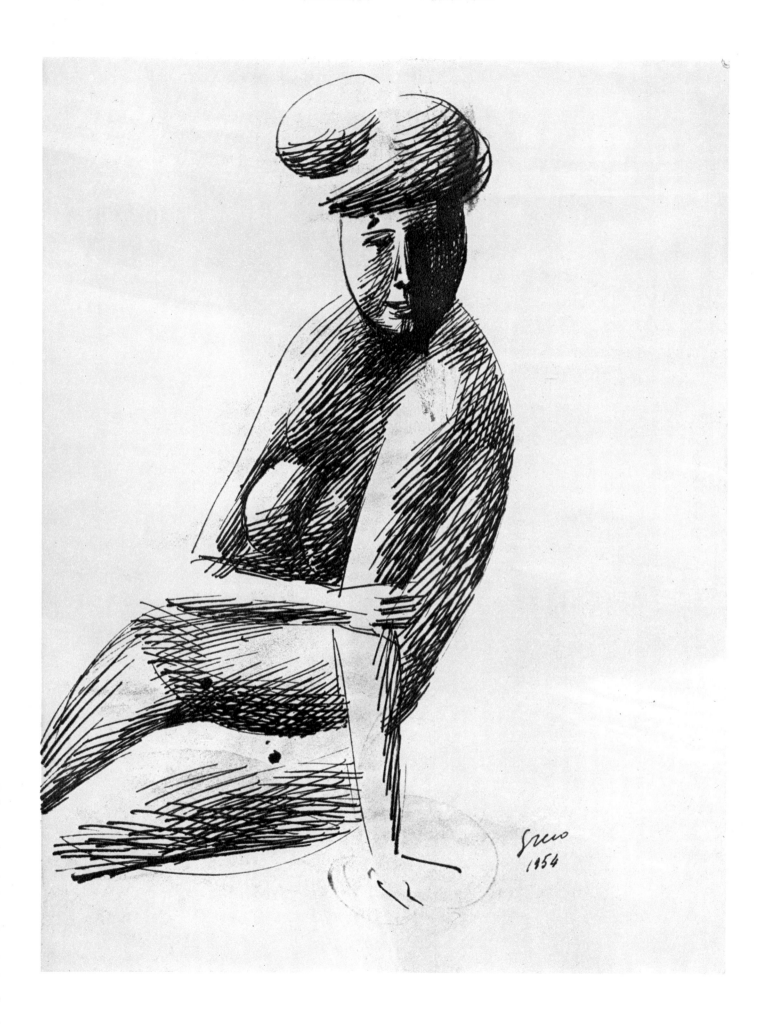

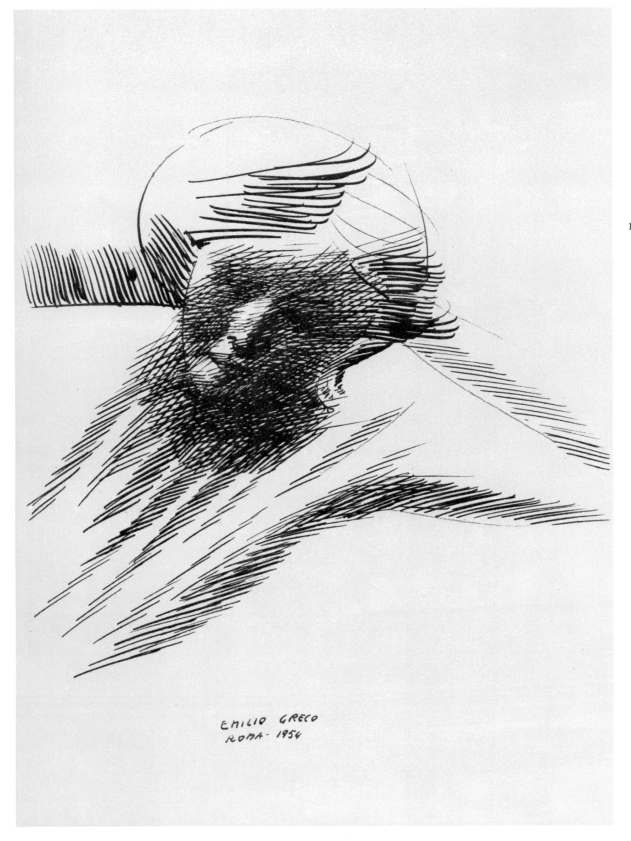

137 Study for sculpture, 1954.
Pen and ink